Hand Lettering

Master Class

Hand Lettering Master Class

A STEP-BY-STEP GUIDE TO
BLENDING, LAYERING AND ADDING STUNNING SPECIAL EFFECTS TO YOUR LETTERED ART

Marcella Astore

PAGE STREET
PUBLISHING CO.

First published in 2022 by
Page Street Publishing Co.
27 Congress Street, Suite 1511
Salem, MA 01970
www.pagestreetpublishing.com

Distributed by Macmillan, sales in Canada by The Canadian Manda Group.

26 25 24 23 22 1 2 3 4 5

ISBN-13: 978-1-64567-594-5
ISBN-10: 1-64567-594-7

Library of Congress Control Number: 2021952251

Cover by Marcella Astore. Book design by Meg Baskis for Page Street Publishing Co.
Illustrations by Marcella Astore

Printed and bound in China

Dedication

THIS BOOK IS DEDICATED TO MY
FAMILY, ESPECIALLY MY PARENTS,
WHO HAVE ALWAYS SUPPORTED ME
IN ALL OF MY ENDEAVORS.

Contents

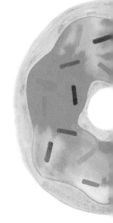

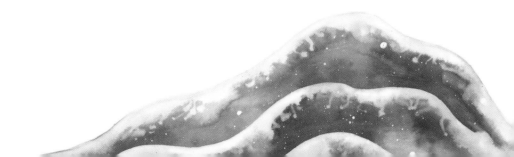

Introduction

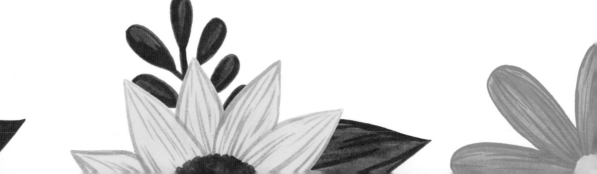

Hi! My name is Marcella and I am so excited that you're interested in learning some of my favorite lettering techniques. This book is full of my tips and tricks for adding beautiful scenes and patterns inside of your lettering. These in-depth, step-by-step tutorials show my full process for creating some of my favorite lettering projects, along with my guidance on how you can easily replicate them yourself.

I'm a lettering artist who specializes in creating vibrant lettered art. When I first started lettering, I stuck to the usual beginner projects, like lettering with one marker at a time, doing some simple blending and playing around with different styles until I found my own. Since then, I've become known in the lettering community for pushing the limits on what can be added into lettering, from landscapes to patterns to turning the letters into something else entirely.

I took the definition of lettering (the art of drawing letters), rather than calligraphy (the art of writing), to heart while creating these projects. Not only will you learn how to draw the letters themselves in various styles, but you'll also learn how to draw a myriad of designs inside of your lettering. It helps if you have some basic knowledge of lettering, but that's not required. I'll go over some of my favorite lettering styles and basic techniques before diving into the full tutorials.

These projects are detailed and will require time and patience, but once you see your finished work, it'll be worth it.

Marcella Astore

RECOMMENDED SUPPLIES

Although practice is the most important step in creating beautiful lettering pieces, supplies can also play a big role in how your projects turn out. Since lettering has become a pretty popular hobby, there are a bunch of options available. I've tried out a lot of different choices and have figured out which ones work best, especially for the types of projects you'll find in this book.

From markers to paper to paintbrushes, there have been so many times that I attempted to use something that either wasn't made for what I was trying to do or just didn't work well. Regardless of whether you're an absolute beginner or a lettering pro, using the wrong supplies can hinder your artwork and discourage you from continuing to letter, but using the right supplies can enhance your artwork. I've compiled all of my favorite tried-and-true lettering supplies below!

BRUSH PENS

First up are the most-used items for these projects—brush pens. One of the most important factors in choosing which brush pens to use, especially in the following projects, is whether or not they have water-based ink. Luckily, the majority of the most popular large brush pens, including all of the ones I've listed, are water-based!

While not every project requires water-based ink, many do since you'll be doing lots of blending with water. If you try to add water to a marker that doesn't have water-based ink—for example, an oil-based paint marker or an alcohol-based marker—the water will not allow the ink to lift and move around. If you can't move the ink around from the marker you used, you won't be able to use the blending methods I use for the projects in this book. You can easily use a water-based brush pen for the projects that don't require blending, but that doesn't work the other way around.

In terms of sizes, I used large brush pens for all of the upcoming projects, but I've included some of my favorite small brush pens as well!

LARGE BRUSH PENS: These are what you'll want to use to create large lettering that really pops! All of these are sold both in sets and as individual markers, so you have lots of options to choose from.

TOMBOW DUAL BRUSH PENS: These are my absolute favorite brush pens and what I used for all of the projects in this book. They have the firmest tip out of these three options and don't release so much ink that the lettering looks wet before it dries, which is what I prefer, especially

when I'm planning on blending the ink with water. Although no single 10-pack set will have all the colors needed to complete every project in this book, I really love the Bright, Primary and Pastel 10-packs because they give you a wide variety of colors that encompass most of the colors used in the upcoming projects. If you do grab a pack, keep in mind that you may also need gray brush pens in order to use my method of sketching and adding shadows. More on that soon!

ECOLINE BRUSH PENS: These have softer tips than the Tombow Dual Brush Pens and release slightly more ink when you letter with them. They naturally create a nice gradient effect as you add and release pressure while lettering, which can be a nice touch, especially in cases when you don't blend the ink with water afterwards.

KARIN BRUSHMARKER PRO: The defining factor of these is that they release a lot of ink when you use them. This makes the colors vibrant but can also lead to longer drying times. Since so much ink comes out at once, you can sometimes get a watercolor bleed effect by using just the markers, which would otherwise only happen when you also use a paintbrush and water.

SMALL BRUSH PENS: These could be used for some of the smaller, less important words in lettering designs, especially articles and filler words.

TOMBOW FUDENOSUKE BRUSH PENS: These have a hard tip, which means that the contrast in size between the upstrokes and down-strokes won't be too large. They are especially great for beginners since the firmer tip is easy to control. I mainly use these in black, but they also come in a bunch of colors.

PENTEL SIGN BRUSH PENS: These have a softer tip and write very smoothly. A huge plus with these is that they have a very wide color range, which makes them easy to incorporate into whatever color scheme you are using.

TIP: While brush pens are always recommended for lettering, some normal markers can also be pressure sensitive. If you decide to try lettering with something other than brush pens, you'll want to avoid bullet or chisel tip markers. Markers that have a relatively flexible tip and come to a point are your best bet. My favorite regular markers that can double as brush pens are Crayola Broad Tip Markers and Crayola Super Tips.

COLOR SWATCHES

Picking accurate colors can be difficult, so I've compiled a list of all the large brush pen colors needed to complete the projects in this book, along with the exact names and/or numbers of each shade. I used Tombow Dual Brush Pens throughout the book, but I've also included similar shades in other recommended brands as well.

LIGHT PINK
Tombow Dual Brush Pen: 761
Royal Talens Ecoline Brush Pen: 381
Karin Brushmarker PRO: Pale Pink

PINK
Tombow Dual Brush Pen: 723
Royal Talens Ecoline Brush Pen: 361
Karin Brushmarker PRO: Rose Pink

DARK PINK
Tombow Dual Brush Pen: 755
Royal Talens Ecoline Brush Pen: 337
Karin Brushmarker PRO: Magenta

LIGHT YELLOW
Tombow Dual Brush Pen: 062
Royal Talens Ecoline Brush Pen: 226
Karin Brushmarker PRO: Almond

YELLOW
Tombow Dual Brush Pen: 055
Royal Talens Ecoline Brush Pen: 201
Karin Brushmarker PRO: Canary

DARK YELLOW/GOLD
Tombow Dual Brush Pen: 026
Royal Talens Ecoline Brush Pen: 259
Karin Brushmarker PRO: Gold

LIGHT GREEN

Tombow Dual Brush Pen: 173

Royal Talens Ecoline Brush Pen: 665

Karin Brushmarker PRO:
Sulphur Yellow

GREEN

Tombow Dual Brush Pen: 245

Royal Talens Ecoline Brush Pen: 600

Karin Brushmarker PRO: Grass

DARK GREEN

Tombow Dual Brush Pen: 249

Royal Talens Ecoline Brush Pen: 656

Karin Brushmarker PRO: Lush Green

LIGHT BLUE

Tombow Dual Brush Pen: 451

Royal Talens Ecoline Brush Pen: 580

Karin Brushmarker PRO: Arctic Blue

BLUE

Tombow Dual Brush Pen: 476

Royal Talens Ecoline Brush Pen: 505

Karin Brushmarker PRO: Cyan

DARK BLUE

Tombow Dual Brush Pen: 565

Royal Talens Ecoline Brush Pen: 506

Karin Brushmarker PRO: Royal Blue

TEAL

Tombow Dual Brush Pen: 373

Royal Talens Ecoline Brush Pen: 661

Karin Brushmarker PRO: Cool Aqua

PURPLE

Tombow Dual Brush Pen: 636

Royal Talens Ecoline Brush Pen: 548

Karin Brushmarker PRO: Violet Blue

LIGHT BROWN

Tombow Dual Brush Pen: 942
Royal Talens Ecoline Brush Pen: 439
Karin Brushmarker PRO: Rosewood

BROWN

Tombow Dual Brush Pen: 977
Royal Talens Ecoline Brush Pen: 416
Karin Brushmarker PRO: Cocoa

DARK BROWN

Tombow Dual Brush Pen: 879
Royal Talens Ecoline Brush Pen: 440
Karin Brushmarker PRO: Sepia

RED

Tombow Dual Brush Pen: 847
Royal Talens Ecoline Brush Pen: 334
Karin Brushmarker PRO: Lipstick Red

MAROON

Tombow Dual Brush Pen: 757
Royal Talens Ecoline Brush Pen: 441
Karin Brushmarker PRO: Burgundy

ORANGE

Tombow Dual Brush Pen: 925
Royal Talens Ecoline Brush Pen: 237
Karin Brushmarker PRO: Amber

LIGHT GRAY

Tombow Dual Brush Pen: N95
Royal Talens Ecoline Brush Pen: 738
Karin Brushmarker PRO: Cool Grey

GRAY

Tombow Dual Brush Pen: N65
Royal Talens Ecoline Brush Pen: 704
Karin Brushmarker PRO: Cool Grey 2

BLACK

Tombow Dual Brush Pen: N15
Royal Talens Ecoline Brush Pen: 700
Karin Brushmarker PRO: Black

PAPER

I mainly use two types of paper for the projects in this book—mixed-media and printer paper.

MIXED-MEDIA PAPER: This is my favorite and most-used type of paper for blending water-based markers, like the Tombow Dual Brush Pens, using water and a paintbrush. Unlike printer paper, mixed-media paper can hold water well and allow you to take your time while blending since the water won't absorb into the paper too quickly. Plus, you can easily use this paper for projects that don't require blending with water as well! I use Canson XL Mix Media Paper.

PRINTER PAPER: For projects that don't require blending, I sometimes save my mixed-media paper and opt for using printer paper instead. Keep in mind that this paper does not hold water well, so even the marker ink can cause it to fall apart if you layer too much on it. I've found that more than one layer of marker ink will cause normal 20lb (75 gsm) printer paper to begin to peel. I recommend using a thick and bright printer paper, like Astrobrights Premium 28lb (105 gsm) 97 Bright Paper, to avoid having your paper be too dark and/or a bit transparent. This is especially important if you want to photograph your finished work! Since this paper is a bit thicker than the usual 20lb (75 gsm) printer paper, it can typically hold two to three layers of ink before peeling but should still not be used when blending.

MISCELLANEOUS SUPPLIES

- **Light gray brush pen**—for all projects that require a sketch, noted in the "Preparation" section of each project. I use either a Tombow N95 or N89 Dual Brush Pen.

- **Gray brush pen**—for all projects that require highlights, noted in the "Final Touches" section of each project. I use a Tombow N65 Dual Brush Pen.

- **White paint or ink**—for all projects that require highlights, noted in the "Final Touches" section of each project. I use Dr. Ph Martin's Bleedproof White, which is a white watercolor paint. I prefer using a water-soluble white paint like this one because it can be used not only for adding highlights, but also for adding textures and effects to pieces alongside the water-based markers, which you'll see a few times throughout this book. You could use white acrylic paint or acrylic ink instead for the highlights, but keep in mind that you'll also need white water-soluble paint for some projects.

- **Small round paintbrush**—I typically use the Princeton Brush Heritage line, with my most commonly-used size being 01.

- **Black fineliner/small marker**—It's helpful if this does not have water-based ink to prevent it from blending into the water-based brush pen ink.

- **Dip pen**—I prefer to use this for adding highlights, but you can get by without it. It allows you to get crisp, precise lines for highlights and easily lets you add or remove pressure to create tapered ends.

- **Gold watercolor paint or gel pen**—for adding accents. I prefer to use watercolor paint with a paint brush or dip pen because I find it easier to get an opaque line, but a gel pen could also work!

CHARACTERISTICS
AND GUIDES

There are so many ways to letter, which leads to differences ranging from intentionally added flourishes to the slight disparities that come from each artist's personal style. Although defining the "correct" way to letter can be difficult, I've compiled three of my most-used styles along with guidelines to help you recreate them.

While every piece is different and variations are always a fun way to switch it up, these basic guidelines can help you better define what type of look to go for in the upcoming projects. The style I chose to use for each project will always be noted in the "Preparation" section.

SCRIPT STYLE

a b c d e f g
h i j k l m n
o p q r s t u
v w x y z

SCRIPT STYLE

This style is flowy, bouncy and what people typically imagine when thinking of lettering. It's like cursive, but so much better. This style can easily be used for both the main words and supporting words in the upcoming projects. It's my favorite and has become my signature style.

CHARACTERISTICS: This is the quintessential lettering style. To create it, I letter like I normally would, but the main thing that sets this apart is that I double the thickness of the downstrokes. Even though the downstrokes will already be thicker than the upstrokes, this extra step creates as much room as possible for adding in patterns or scenes, which is especially important given the types of projects that are in this book. I typically space out the letters horizontally a bit more than I usually would so that there will be plenty of space available to double the thickness of the downstrokes. Then, it's as simple as going back over the initial letters and adding an extra line on each downstroke.

VARIATIONS: The most common variation to this style is adding flourishes. Flourishes are the ornamental swirls that you may have seen attached to some lettering. I like flourishing with this style in particular because the freeness of the flourishes pairs well with the freeness of this style. I mainly use this style for lowercase letters, but you could also use script uppercase letters.

BLOCK STYLE

A B C D E F G
H I J K L M N
O P Q R S T U
V W X Y Z

BLOCK STYLE

Unlike the Script Style, the Block Style is bold and structured. I use this style strategically to highlight one or two words in a piece since it's so eye catching. The simplicity of the letters means that it pairs well with both Script Style and Print Style. I rarely use the Block Style for the non-focal words in a quote.

CHARACTERISTICS: The most striking feature of this style is its boldness. I based it on some of my favorite striking sans serif fonts, like Impact.

TIP: If you're having trouble freehanding this font, try tracing typed-up letters using Impact or a similar font to start out. You could either type the words you need and print them out to trace or type them on a tablet and use it as a makeshift lightpad, which is my preferred method. Eventually, you'll get a feel for the shape of each letter and it will be easier to freehand them!

VARIATIONS: You can easily vary the thickness and height of the letters in this style to fit your preferences. I like to keep them on the taller side, but you could alternatively make them wider, which could be helpful in adding space for design elements.

PRINT STYLE

A B C D E F G
H I J K L M N
O P Q R S T U
V W X Y Z

PRINT STYLE

This style is structured like the Block Style but has some more room for personalization. I often use this style for non-focal words, but I've also included some examples of it being used for the main word in some of the upcoming projects. If you're new to lettering but still want to practice adding design elements into your lettering, this is a great font to start with since it's similar to most people's handwriting.

CHARACTERISTICS: This style is relatively straightforward, especially if you stick with all uppercase letters like I usually do. The down-strokes can easily be made thicker or thinner to accommodate your design and the width can be adjusted based on what type of look you're going for.

VARIATIONS: This is arguably the simplest style, which means that it has lots of room for adding variation. You can easily curve the straight lines to give a softer effect, make the letters Monoline or even add serifs!

Before You Start

HOW TO PREPARE FOR YOUR LETTERING PROJECTS

This book is full of a bunch of different ideas and techniques, but the great thing about them is that all of them start and finish almost the exact same way. This chapter will show you how to begin each project by creating a foundational sketch to build upon. Then, you'll learn how to add finishing touches to the end of a project by using shadows and highlights to really put it over the top.

CREATING A SKETCH

Before you start adding fun elements to your lettering, you need to come up with a plan. I almost always sketch out my lettering before adding in color, especially if the project starts off with blending, since you'll be building the letters bit by bit instead of lettering normally. If the project starts by just lettering the quote with a brush pen, you can skip this step if you feel comfortable.

WHAT TO USE

You may be inclined to use a pencil, but that's not always the best idea on its own. Pencil marks will need to be erased, which can cause problems if you try erasing them after adding layers of colorful ink. Even if you give the ink time to dry, the pencil lines will be significantly harder to erase after the ink is layered on top.

All of these problems can be easily solved with my favorite tool for sketching: a light gray brush pen. Since the color is so light, almost any color you layer on top will cover it up, which really sets apart this approach to sketching. There's no need to erase your sketch, which means that there are fewer opportunities to mess up your project, like having the paper peel or bend while erasing.

Plus, the fact that this brush pen is pressure sensitive, rather than Monoline like a pencil, is extremely helpful when it comes to projects where you're building the letters bit by bit instead of lettering normally, since you'll see how thick and thin the downstrokes and upstrokes should be.

> **TIP:** If you don't have a light gray marker, another light color could work well depending on the colors you're planning on blending. If you're using markers that are all shades of the same color, I recommend using a lighter version of that color. For example, if you're planning on blending different shades of blue in your piece, use a lighter shade of blue for your sketch.

MY SKETCHING PROCESS

Start by lettering the word(s) lightly with a pencil. The less pressure you use, the better, since it makes it easier to erase the pencil lines later on. This is your time to tweak the layout until you settle on something you like. As long as your pencil sketch is relatively light, you shouldn't have too much of a problem erasing it, even after going over it with the light gray marker. You can erase with a bit of a heavier hand than usual during this step since you don't need to worry about colors smudging.

Then, take a light gray brush pen and letter over the pencil sketch to create a base for your lettering. After the light gray ink dries, erase the pencil lines. They should erase fairly easily since they are light, and even if the gray smudges, it won't be too visible since the color is so light. When it comes time to start adding color, whether or not you plan on blending afterwards, you can do that directly over this sketch!

BLENDING TIPS & TECHNIQUES

One of my go-to techniques for making my lettering really pop is blending. This popular technique is a fun and easy way to add some extra color and texture to your lettering. In essence, blending is the overarching term for combining colors within letters. I typically use a paintbrush and water to blend the ink, but you could also use a water brush or colorless blender. Even on its own, blending can be a beautiful way to enhance your lettered art. By learning how to blend and adding this technique into the upcoming projects, you'll really be able to take your lettering to a whole new level.

Start by creating your lettering sketch using the sketch technique shown on page 26, "Creating a Sketch." This method is especially important for blending since you'll be coloring in the sketch bit by bit. Make sure to use a thicker paper, like mixed-media paper, to blend effectively—see the "Recommended Supplies" section on page 10 for more details.

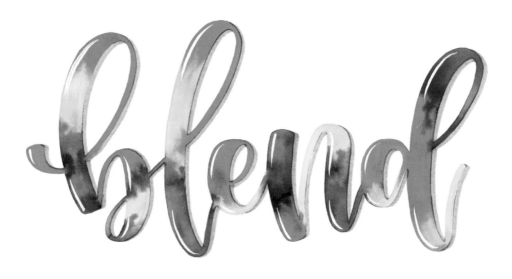

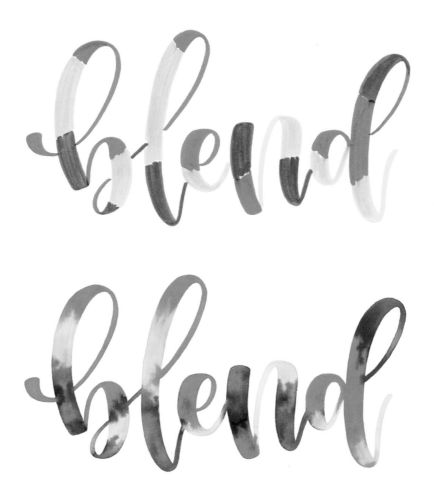

I like to break up my letters into sections and fill each section in with a color. For letters that only go up to the midline, like "a," "e" and "n," I break up each downline into two sections, with each section getting a different color. For letters that go above the midline or below the baseline, like "g," "b" and capital letters, I break each letter up into three sections. This way, each section of color is roughly the same length regardless of the height of the letter.

For designs where you're only using two colors, just alternate between the two, following the same three-section setup. For example, if it's a tall straight line with three sections, the top and bottom would be one color and the middle would be the alternate color.

My favorite and most-used style of blending is this beautiful tie-dye style with lots of bleeds. Use short strokes to blend the colors together with your paintbrush and water, aiming to keep each color distinct even when it crosses into another color's section.

COMMON MISTAKES

There are a lot of small variations that can change the way your blending looks. For example, adding too much or too little water can affect your blending. If you use too little water, the ink won't budge from the page. If you use too much, the color can become less vibrant and even begin to bleed into the thin creases in the texture of the paper. This can create a softer look with less defined bleeds, which can look nice in some instances, but also comes with added risks. For example, if you are using contrasting colors, it makes it more likely that the colors will end up looking muddy. Also, more water means that it will take longer to dry, which adds to the total time it takes to complete your project. You want to saturate the paintbrush with just enough water so that the ink moves easily but still looks vibrant. Different paintbrushes will be able to hold different capacities of water, so this may take some trial and error, but eventually you'll find the right amount! It can be helpful to practice the blending technique you want to use on a practice page before doing it on your actual lettering project.

NOT ENOUGH WATER

THE RIGHT AMOUNT OF WATER

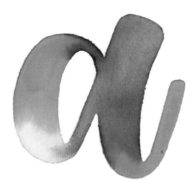

TOO MUCH WATER

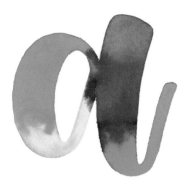

BLENDED WITH WATER

Another common mistake is going over the ink too roughly or for too long. Both can lead to a very smooth blend which looks very nice, but isn't what we're going for with this paintbrush technique. The key to achieving the defined bleeds is not to smooth over the colors too much with the paintbrush when blending, since you're not aiming for a smooth gradient.

If you want to aim for a smoother gradient, I recommend using either a colorless blender marker or blending using just the colored brush pens and tapering the colors into each other. This can make the color look more vibrant than it would have if you used a paintbrush, while still creating a smooth blend.

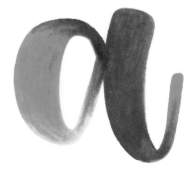

SMOOTH BLEND WITH COLORLESS BLENDER MARKER (SATURATED)

SMOOTH BLEND WITH WATER (NOT AS SATURATED)

ADDING SHADOWS & HIGHLIGHTS

For most of your lettered art, there are two things you should add after you finish the design: shadows and highlights. Adding these elements will give your lettering a glossy 3D effect that makes it seem like the letters are popping off of the page. Conveniently, the process for adding these will only vary slightly from project to project, so once you get the hang of it, you'll be able to add shadows and highlights wherever they're needed!

ADDING SHADOWS

A good way to imagine where the shadows go is to imagine a light shining on your lettering. If the light is coming from the left above your lettering, which is where I like to imagine it, then the shadows would go to the right of your lettering. When you get to the parts of your lettering that are horizontal, like the line that crosses a "t," the shadow goes underneath because the light is coming from above the lettering. Before adding shadows, make sure that the rest of the piece is completely dry to avoid smudging. This is especially important if you blended or added white paint!

To add shadows, take a gray brush pen—I use a Tombow Dual Brush Pen N65—and add lines along the right side of the letters. Although I use a brush pen, I keep the same amount of pressure for all of the shadows regardless of whether they go alongside an upstroke or downstroke.

I add in the shadows before the highlights since the shadows don't need time to dry. This way, you can do the highlights immediately after the shadows and then let everything dry afterwards.

ADDING HIGHLIGHTS

If the light is shining from the same spot as it is when we're creating shadows to the right of the letters, then the highlights should go towards the left. Unlike the shadows, the highlights go on top of the lettering, not completely on the side. These give the letters a smooth and glossy effect.

There are a few different ways to add highlights, but my preferred method is using white paint and a dip pen. To add the highlights, dip your nib in white paint and add lines to the inside edges of your letters. Start the line thin, then add pressure near the middle and taper it off again at the end. I like to add a highlight at the top and bottom of each downstroke.

Sometimes, I prefer not to add highlights to a piece, like if it has a very busy pattern or the highlights would cover up an important aspect of the design. Skipping the highlights gives it more of a flat look, which can be useful if that's what suits the style of the design.

> **TIP:** If you don't have a dip pen, you could use a small paintbrush dipped in white paint to get a similar effect. A white gel pen could also work, but I tend to avoid that option because the ink in most white gel pens isn't opaque enough to create a bright white highlight in just one layer.

Specific guidelines regarding adding shadows and highlights will be in the "Finishing Touches" section of each project!

Botanicals

This chapter is all about adding beautiful florals to your lettering. I'll be teaching you some of my favorite techniques that include flowers, leaves and vines. Not only will you learn how to add these beautiful botanicals inside and around your lettering, but you'll also learn how to create letters out of them!

One of the reasons why I love this chapter is because it is so customizable. From the colors you use to the types of flowers you choose, so many aspects of these projects can be changed to fit your preferences. Keep reading to see how I create botanical lettering and start thinking about how you can personalize them!

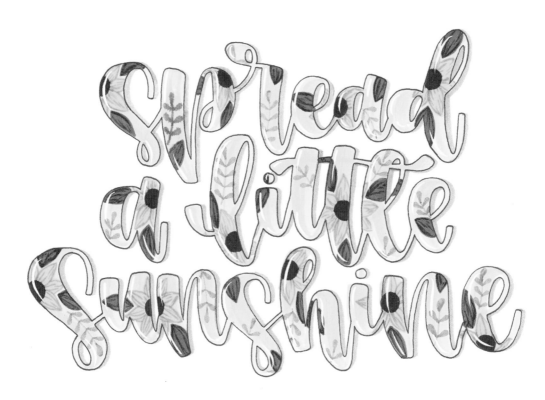

SUNFLOWER SCRIPT

This sunflower lettering project brings the warmth of summer to your lettering! Sunflowers are one of my favorite flowers, so I love adding them into my lettering. Of course, you could do this style with any type of flower or even add in two types of flowers! I think that roses, daisies and/or lilacs could look really nice in this project.

If you decide to change the color of this base layer, I recommend sticking to lighter colors, since you want the flowers to still be visible when you draw them over it. I chose yellow because it won't drastically affect the color of the sunflowers and leaves. For example, if I had chosen light blue for the base, the sunflowers would have ended up with a bit of a green tint to them since the yellow ink layered over light blue would create green. Keep that in mind, especially if you decide to use a different color for the flowers!

MATERIALS NEEDED

- Brush pens: light yellow, yellow, dark yellow/gold, brown, light green, green, dark green & gray—see the color palette on page 12 for specific brand color numbers
- Paper: mixed media
- Pencil & eraser
- Black fineliner
- Dip pen & white paint

1

2 A

2 B

STEP ONE: Take your light yellow marker and letter "spread a little sunshine" in the Script Style (page 18).

STEP TWO: Using a pencil, sketch out some sunflowers on top of the lettering. Don't be afraid to continue the sunflower from one letter to the next or even from one line to the next, like I did with the "u" and "n" in "sunshine."

To create the sunflower shapes, start at the center and draw pointed ovals, like footballs, going around the center for the petals. You want one of the points from each petal to touch the center of the flower. I like to draw an odd number of petals to avoid having the flower be symmetrical. You want the petals to overlap a bit like sunflower petals do.

Then, fill in the sections of your flowers that fit inside of the letters with your yellow marker. Once the marker ink has dried, erase the pencil sketch.

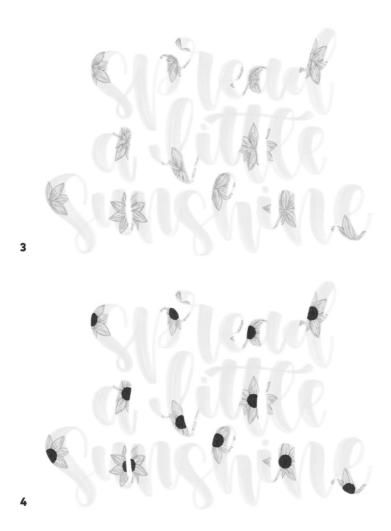

3

4

STEP THREE: Next, take your darkest yellow marker and draw short thin lines over the yellow base following the shape of the petals. You can get these thin lines by either drawing very lightly with the brush tip of your marker or using the bullet tip (if applicable). Continue this in the center of each petal to add some depth.

STEP FOUR: Using your brown marker, add a small dot to the center of each sunflower. Don't worry if the dots aren't perfect. I actually prefer uneven and oddly shaped dots because I think that it looks more natural.

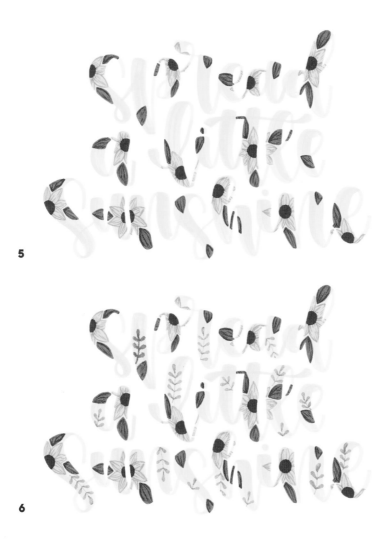

5

6

STEP FIVE: Now, it's time to add in some leaves. The process for drawing the leaves is almost identical to the petals, but in green.

Next to the flowers, draw pointed ovals—the same shape as the petals—with your green brush pen. Then, take your dark green marker, add thin lines and blend over the leaves.

STEP SIX: To fill in extra spaces, add some vines by drawing a thin line with your light green marker and adding teardrops on either side going down the length of the line.

TIP: Most brush pens can easily create a teardrop shape if you press them down on the page. The amount of pressure you put on the pen will determine how big it ends up being, with more pressure leading to a larger teardrop. This can help speed up the tedious process of adding tiny leaves to the vines.

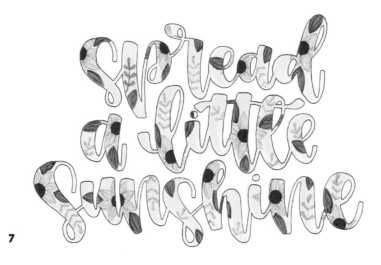

7

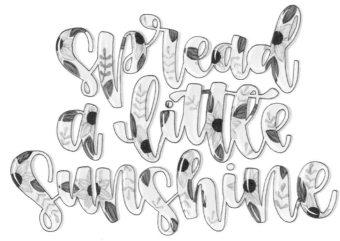

STEP SEVEN: Since the base of this project is so light, it can be hard to define where the letters begin. To help make the words more legible, take your black fineliner and outline your lettering.

FINISHING TOUCHES: Add shadows using the gray brush pen and highlights using the dip pen and white paint as shown on page 32, "Adding Shadows & Highlights."

TIP: I typically add outlines near the end of the project because, at this point, the colors are darker than the original light gray from the sketch, even in a piece like this where the base is still pretty light. This makes it easier to see where the edges of your lettering are and can help prevent mistakes. Plus, if you made adjustments or went outside the lines of your sketch, you can outline around it and make it seem like your mistakes were intentional choices.

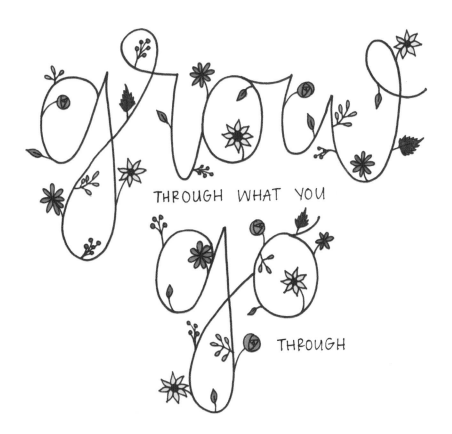

MONOLINE
FLORAL VINES

This project is simple but beautiful, which makes it great for both beginners and experts alike. I used a Monoline version of the Script Style for this piece and added all of the design elements outside of the letters, so there's no pressure about making sure that your design fits inside.

There are plenty of opportunities to customize this project, from changing the colors of the flowers to changing the theme altogether! I've added a few options for flowers and leaves that you can mix and match if you'd like to try something different.

You could also change the theme entirely, like by replacing the green leaves and bright flowers with warm-toned fall leaves.

MATERIALS NEEDED

- Black fineliner (plus a second, thinner black fineliner if desired, see step six)
- Brush pens: pink, dark pink, light green, green, dark green, yellow, blue & black—see the color palette on page 12 for specific brand color numbers
- Paper: mixed media or printer

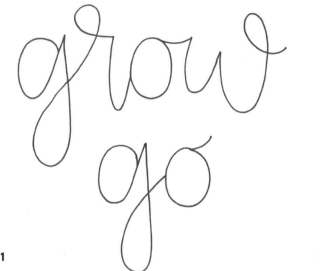

1

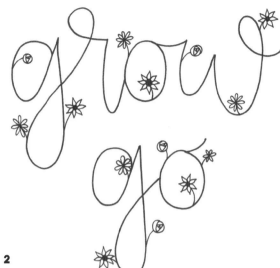

2

STEP ONE: Start by lettering the words "grow" and "go" using your black fineliner to create the vines, leaving some space in between the words to add in the rest of the quote later on. I did this using the Script Style (page 18), but since the fineliner is a Monoline pen, I didn't vary the pressure to create a difference in width between the upstrokes and downstrokes.

STEP TWO: Add flowers surrounding the words using the same fineliner, making sure to leave space for leaves and other floral elements along the vines. Connect each flower to the main vine with a curved line.

TIP: If you need some inspiration, below are a few of my favorite easy-to-draw flowers.

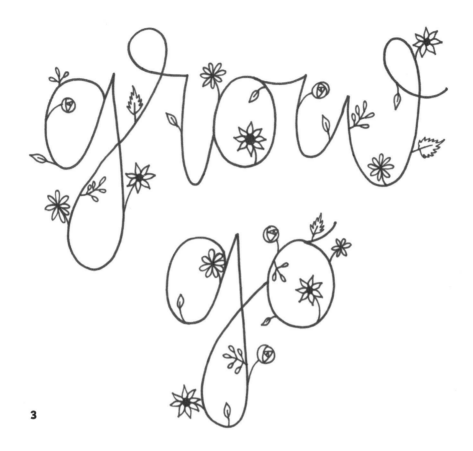

3

STEP THREE: Draw leaves coming out from the vine with your black fineliner. I drew three types of leaves for this step, but you can just do one if you'd like.

TIP: If you need some inspiration, below are a few of my favorite leaves to draw.

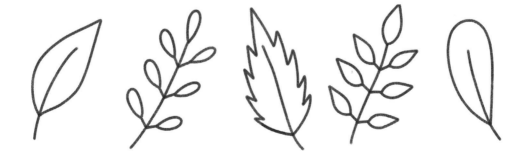

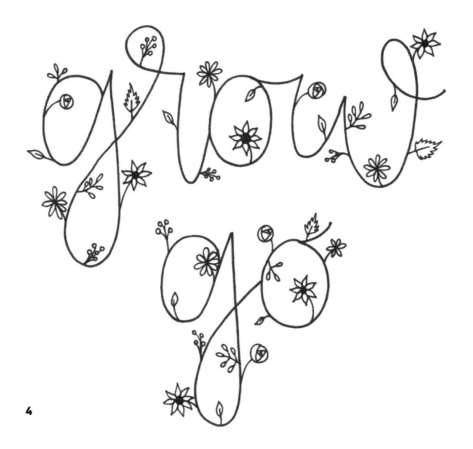

4

STEP FOUR: Now it's time to add in more elements to fill in any extra spaces, like smaller flowers and/or leaves. I recommend sticking to smaller elements so that they easily fit into any spaces you need to fill.

TIP: If you need some inspiration, below are a few of my favorite easy-to-draw filler florals.

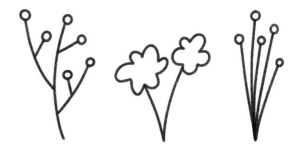

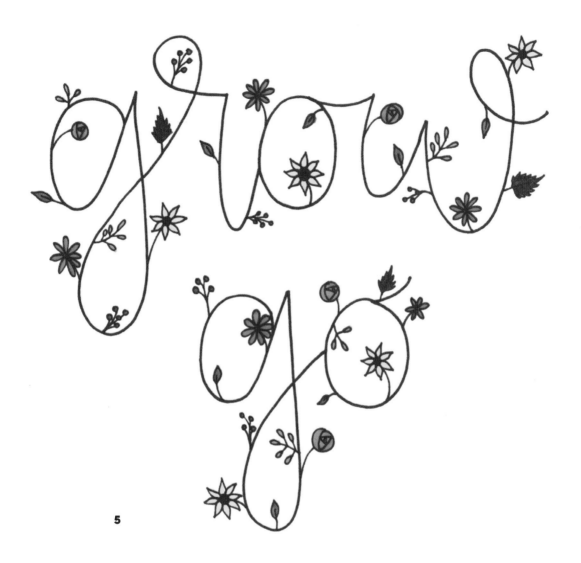

5

STEP FIVE: Next, color everything in! I went with pink for the roses, dark pink for the flowers with round petals, three shades of green for the three types of leaves, yellow for the sunflowers and blue for the filler florals.

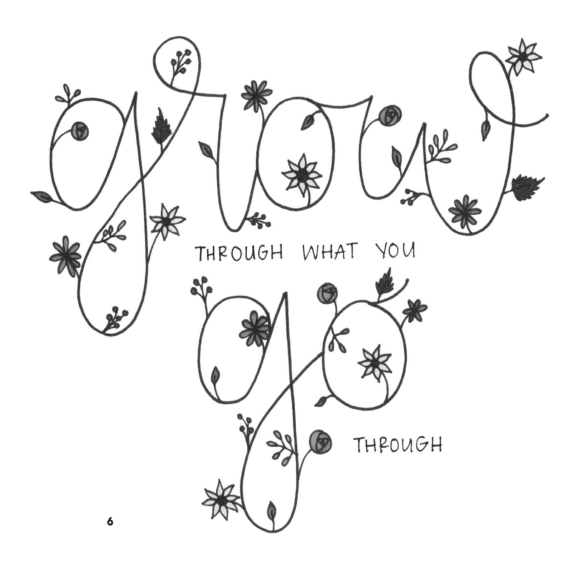

grow

THROUGH WHAT YOU

go

THROUGH

6

STEP SIX: To finish the project, letter the words "through what you" under "grow" using the Print Style (page 22) with a black fineliner. I used a thinner one than the one used in the previous steps to add some variety, but you could also use just one fineliner for this entire project. Then letter the word "through" under "go" using the same Print Style and fineliner to complete the quote.

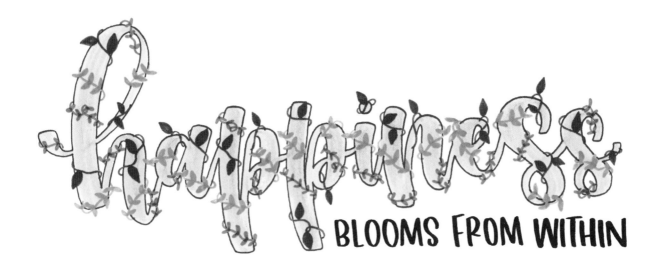

happiness BLOOMS FROM WITHIN

WRAPPING VINES & LEAVES

Let's take a break from flowers and focus on flowing leaves and vines. This project focuses less on the lettering itself and more on what's going on around it. You'll get a sense of working with depth and using simple lines to create elements that look 3D in this project, as the vines need to look like they are wrapping in front of and behind the letters.

In this design, I stuck with shades of green for the leaves, but you can choose any colors and shapes you'd like for the leaves. For example, I think this project would look great with warm-toned fall leaves or even black and gray leaves for a more muted approach.

Like in most of the other projects in this chapter, pastel colors work best for the base. As you learned in the "Sunflower Script" project (page 36), remember that the color of the base may alter the colors you use for the leaves when you layer them on top. In this project in particular, I find that cool-toned pastels work best because they don't affect the shades of green as much.

MATERIALS NEEDED

- Brush pens: light blue, light green, green, dark green & black—see the color palette on page 12 for specific brand color numbers
- Paper: mixed media
- Black fineliner

1

2

STEP ONE: Start by lettering "happiness" in the Script Style (page 18) using your light blue marker.

STEP TWO: Using your three green markers, draw wavy lines wrapping around the letters for the vines. Alternate between colors for each vine you draw so that there is some variation. For this step, less is definitely more, as you don't want the letters to become crowded once you start adding in more details.

While you want it to look like the vines are all connected when they wrap in front of and behind your lettering, they don't actually have to be. It will be very tricky to track this once all the vines and leaves are in place, so just focus on creating a nice balance of color in terms of where the vines fall.

3

4

STEP THREE: For each vine color, pick a type of leaf to draw. I chose large spaced-out pointed ovals for the dark green, small teardrop shapes for the green and small pointed ovals for the light green. Don't be afraid to let some of the leaves fall outside of the lettering but try not to let it happen too often to keep each letter well defined. Make sure to match the color of the leaves to the color of the vine that they are on.

STEP FOUR: To better define where the base layer of the letters is, outline the letters using your black fineliner, skipping over any spots where the vines fall outside of the lettering.

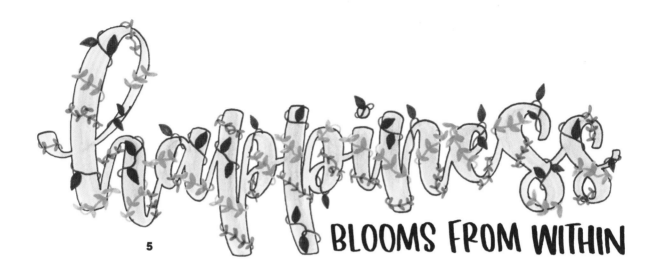

5 happiness BLOOMS FROM WITHIN

STEP FIVE: Using the Print Style (page 22), write "blooms from within" using a black brush pen underneath your lettering to finish the quote. I chose the Print Style because it contrasts with the bounciness of the Script Style, but you could also use the Script or even Block Styles for this step.

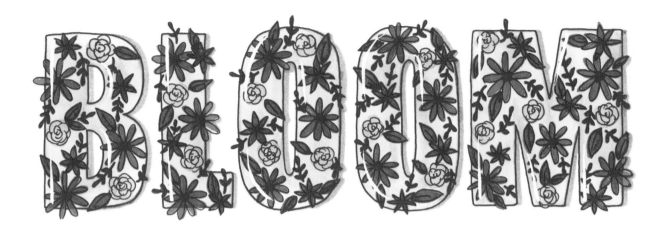

FULL FLORAL GARDEN

Have you been paying attention to all of the different leaves and flowers I've been showing in the previous projects? I hope so, because this is the time to add them all into one big project!

This pretty floral pattern takes advantage of all of the different floral elements you've seen throughout this chapter. You'll not only be lettering but you'll also be learning how to fill the letters with a collage of florals without making the letters look crowded or illegible. Feel free to switch up the types of flowers used or even add a few more on top of what's shown in this project!

While the Script or Print Style could also work for this project, I prefer the Block Style because I think that the structure of the letters lends itself well to the busy floral pattern, making it easier to read.

MATERIALS NEEDED

- Brush pens: light gray, gray, light blue, blue, pink, yellow, green & dark green—see the color palette on page 12 for specific brand color numbers
- Paper: mixed media
- Small round paintbrush & water (optional)
- Black fineliner
- Dip pen & white paint

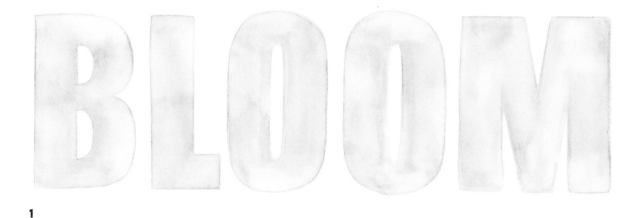

1

PREPARATION: Start this piece by sketching out the word "bloom" in the Block Style (page 20) using a light gray marker.

STEP ONE: Fill in your letters with a pastel marker. I chose a light blue marker because it matches nicely with the colors I chose for the flowers and leaves, but almost any pastel color could work. Be mindful of the fact that the color you choose may slightly change the color of the flowers and leaves you draw on top, which is why I recommend picking a light color.

Even though the base of this piece only uses one color, I went over it with a paintbrush and water, as if I were blending multiple colors instead of just one. This is optional, but I chose to do it because it creates a more even finish, smooths out any overlapping marker lines and can make the base less vibrant, which is helpful when it comes to layering the flowers and leaves on top. Either way, you'll be covering up most of the base in future steps, so it won't make too much of a difference.

TIP: I recommend not choosing green for the base color because it might overpower the piece once you add in leaves later on. If you'd like to use green as the base, in that case black, gray or teal leaves would work better.

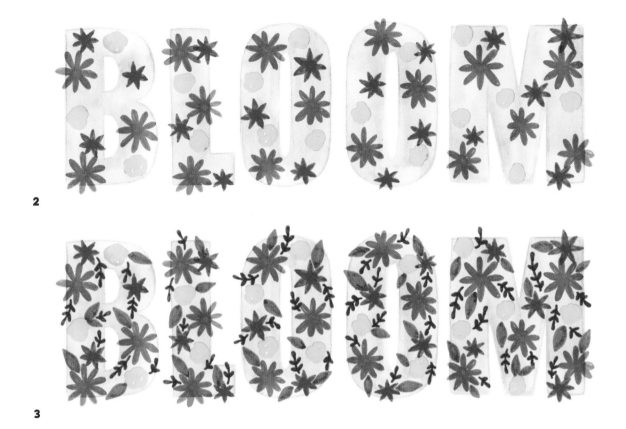

2

3

STEP TWO: Using each of your three colors, start adding flowers inside of your lettering. Make sure to space them out a bit since you'll be adding in leaves and vines later on.

I started out with the large pink flowers since they're the biggest. Make sure to leave lots of room in between them for all of the other details. Then, I added in some smaller yellow and blue flowers to fill in some of the extra space. Since these are so small, they don't need to be super detailed.

STEP THREE: Next, add leaves and vines to fill in the gaps between flowers. For the leaves, I drew small green pointed ovals to fill in as much of the blank space as I could. Then, I added in some vines by drawing a line with my dark green marker and adding some small teardrop shapes on either side and at the end. I chose not to have the leaves overlap or come out from behind the flowers to keep them from looking too crowded or covering up too much of the blue base.

TIP: If you need some inspiration for the flowers and leaves, check out the "Monoline Vines" project (page 41).

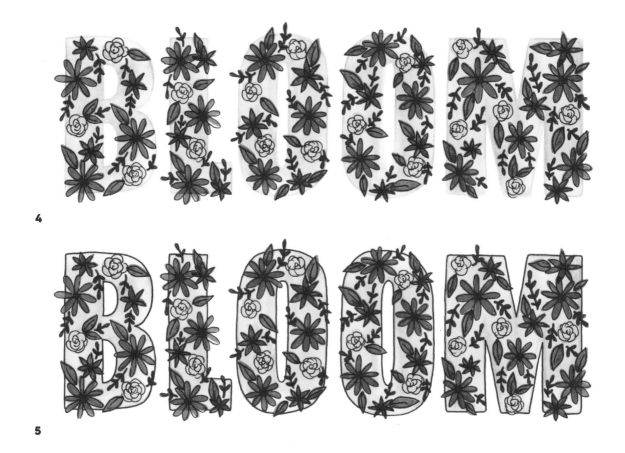

4

5

STEP FOUR: To help the flowers become more defined, take your black fineliner and loosely outline all of the small details. I outlined all of the small floral elements and then added some extra lines to define the petals of the yellow flowers, the centers of the pink and blue flowers and the veins of the leaves.

STEP FIVE: Then, using the same black fineliner, outline the letters. If any of the flowers or leaves went outside of the letter, outline up to the point where they start, skip over the portion that sticks out and continue with the outline so that it looks like that flower or leaf is coming out from the letter.

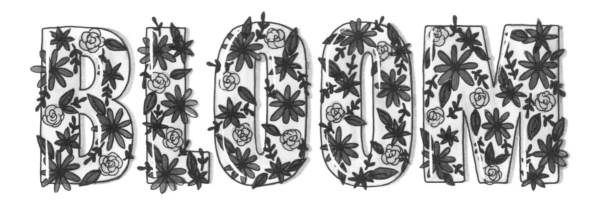

FINISHING TOUCHES: Add shadows using the gray brush pen and highlights using the dip pen and white paint as shown on page 32, "Adding Shadows & Highlights." If a flower or leaf sticks out over where the shadow should be, draw the shadow around it like I did on the "L." For the highlights, you can either add them to the inside left edge like I did or not include them to give more of a realistic and textured look.

Beach Day

Keeping with the nature theme, our next chapter focuses on giving your lettering a beach theme, including the ocean, sand, sunsets and mermaids. These projects make use of water for blending to create beautiful, beach-inspired effects, including one of my absolute favorite techniques: adding waves into your lettering! By the end of this chapter, you'll be able to use water not only to blend, but also to manipulate how white paint can be used by creating partially transparent layers like you'll see in the next two projects.

This fun, scenic chapter will guide you through adding pieces of art directly into your lettering. These beach-inspired lettering projects will give you a little piece of a beach day no matter where you are.

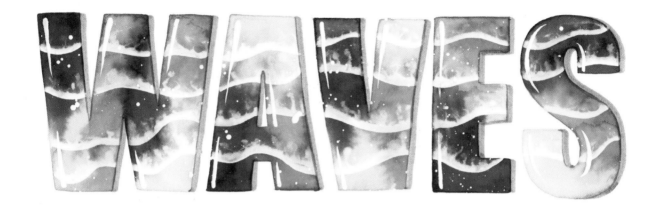

CALMING OCEAN WAVES

This technique was one of the first things I tried after I really got the hang of lettering, and to this day, it is still one of my favorites. I chose the Block Style because it gives the most room for adding in details and showcases the flow of the waves since there isn't a difference in width between the upstrokes and downstrokes. The blended letters look great on their own, but the addition of the white waves really takes it over the top in my opinion.

Since the design is contained within the letters themselves, you can easily switch up the style of the lettering. I've done this technique a few times using the Script Style and although the waves are a bit harder to add into the thinner upstrokes, the lettering still turns out great!

While shades of blue look the most realistic, adding a bit of teal or green would be a great way to keep the authentic look while switching it up a bit. Or you could use other colors entirely, like shades of pink and/or purple, for a more whimsical look!

MATERIALS NEEDED

- Brush pens: light gray, gray, light blue, blue & dark blue—see the color palette on page 12 for specific brand color numbers
- Paper: mixed media
- 2 small round paintbrushes & water
- White paint
- Dip pen

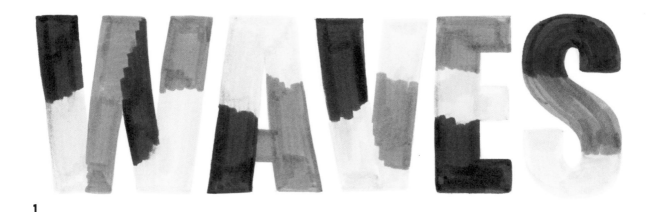

1

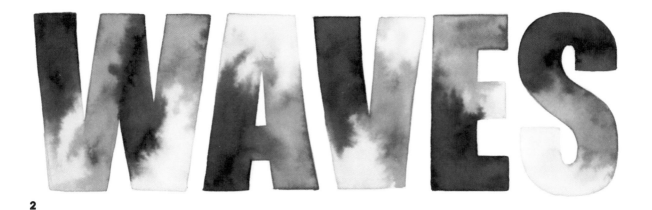

2

PREPARATION: Outline the word "waves" using your light gray brush pen in the Block Style (page 20).

STEP ONE: Color in sections of your letters alternating between the three shades of blue. I purposely chose the lightest and darkest shade of blue I had along with a medium blue. This is because the contrast between the colors allows the places where they meet to be as defined as possible when blending. If your shades of blue are more similar in shade, that's fine too! It just means that your blending will look a bit smoother with less obvious bleeds.

STEP TWO: Blend the colors using water and a small paintbrush. The places where the lightest and darkest shades of blue meet will produce especially vibrant blends, which is great because they will shine through even when you cover parts of them with white paint in the upcoming steps! If there are a few imperfections, don't worry—you'll be able to cover them up later on.

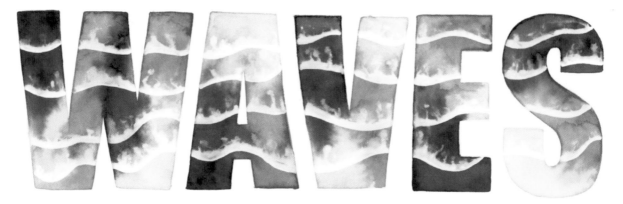

3

STEP THREE: Now, it's time to add the waves! Grab your white paint and two paint brushes, one of which is the one you used to blend in the previous step. To start, draw a wavy line horizontally across the bottom of the "W."

Then, take a clean brush, dip it in water and drag it across the white wavy line, with the tip of the brush just barely touching the top of the line. This will cause a bit of the saturated white paint to bleed into the clear water, creating the effect of a wave with foam.

TIPS: If you only have one paintbrush, you can use one for both the white paint and water, but make sure to clean it each time you dip it in the clean water.

Also, I like to turn the page 90 degrees to the right for this step so that I don't have to worry about my hand accidentally smudging the wet paint. If you're left-handed, try turning to 90 degrees to the left to avoid smudging.

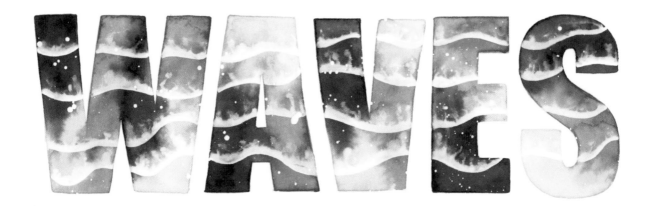

4

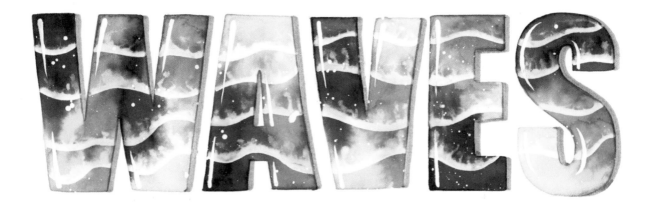

STEP FOUR: Allow the waves to fully dry. Once dried, take a paintbrush and dip it into your white paint. Tap the brush against your finger above the paper so that small drops of paint fall randomly onto the page. This helps to create the effect of a cresting wave. I usually tap the brush roughly 5 inches (13 cm) above the page, but the height you tap from and the location of the drops don't matter too much when creating this effect.

FINISHING TOUCHES: Add shadows using the gray brush pen and highlights using the dip pen and white paint as shown on page 32, "Adding Shadows & Highlights." Since there is already a lot of white in the waves, the highlights will inevitably intersect with some of the white wavy lines. I like to put the tapered point of the highlight in a spot where the wave is blue so that the highlight doesn't get lost in a sea of other white lines.

WAVES ON THE SAND

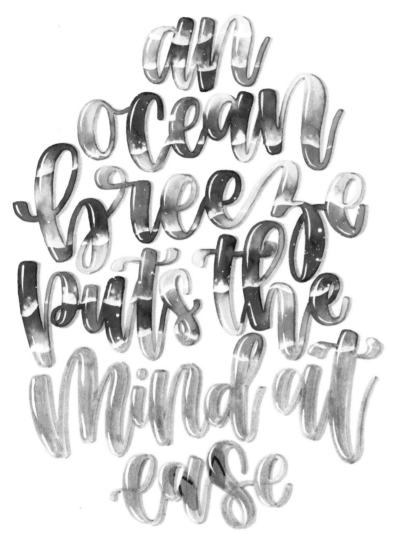

This design combines the waves technique from the previous project with the soft sand of a beach and some fun added details! I chose the Script Style to switch things up a bit from the previous tutorial, but the Block Style or even the Print Style could also work!

I highly recommend looking over the previous tutorial for a more in-depth explanation of the waves portion of this piece. The same options for customization still apply, but this adds another element that you could personalize: the flip-flops! Feel free to change the color and placement or even change them into something else completely, like seashells.

MATERIALS NEEDED
- Brush pens: light gray, gray, light blue, blue, dark blue, light brown, pink & purple—see the color palette on page 12 for specific brand color numbers
- Paper: mixed media or printer
- Pencil & eraser (optional)
- 2 small round paintbrushes & water
- White paint
- Dip pen

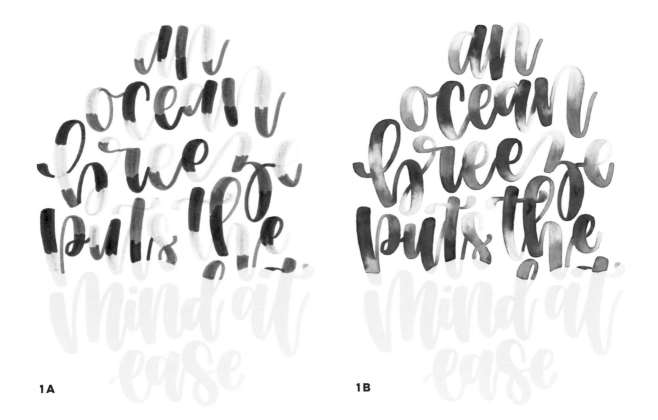

1A

1B

PREPARATION: Sketch "an ocean breeze puts the mind at ease" using a light gray brush pen. I chose to use the Script Style (page 18) for this piece, but the Block Style (page 20) also works well. It's especially important to double the thickness of the downstrokes of the Script Style on this piece so that you have as much room as possible to add in the details.

STEP ONE: Divide your piece into two sections—one for the waves and one for the sand. I like to set aside the top two-thirds of the quote for the waves and the bottom third for the sand. You can either divide this by lightly drawing a wavy line through the piece with a pencil or just making a mental note and freehanding the division.

Then, color in the top two-thirds with your three blue brush pens, blend them up to the dividing line using the same technique as on page 59 and let it dry. Once dry, erase the wavy pencil line if you chose that option.

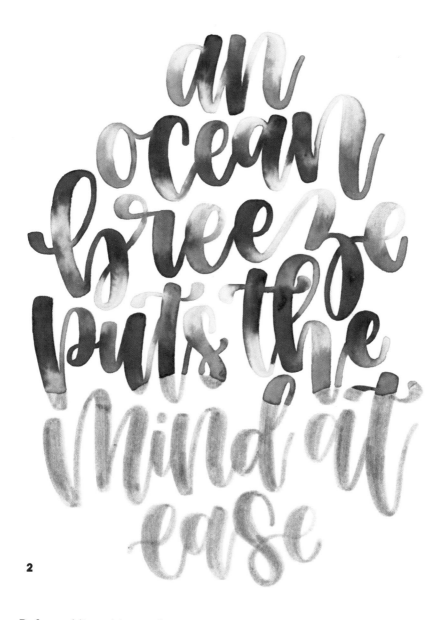

2

STEP TWO: Before adding white to the waves, you'll need to add in the sand. Color in the bottom third of the letters using your light brown brush pen. Optional: To create a smooth finish, blend this layer with water.

The place where the blue and light brown ink meets might look a bit muddy, but that will get covered up when you add white in the next step.

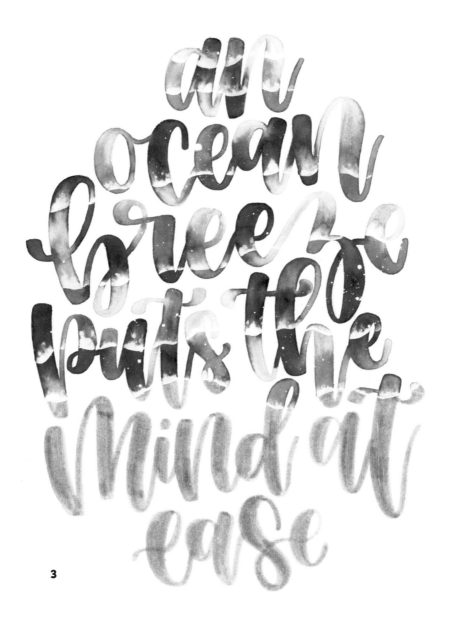

an ocean breeze puts the mind at ease

3

STEP THREE: For the foam on the waves, paint a line of white paint, spread it using water and repeat for each wave. Then, add white foam drops and let everything dry before moving on. For more detailed instructions, see pages 60 and 61.

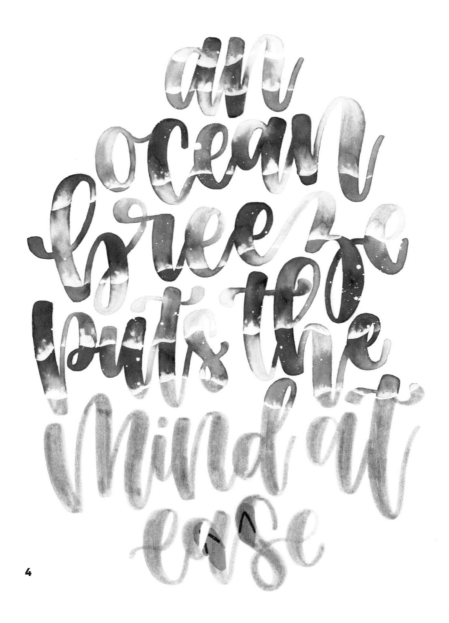

an ocean breeze puts the mind at ease

4

STEP FOUR: Next, it's time to add in a pair of flip flops. For the sole, draw two circles next to each other using your pink marker, with one being slightly larger than the other. Then, connect them in the middle and round out the sides to create a smooth shape. For the straps, take your purple marker and draw two thin lines going from the center of the sole near the top down to the sides. Repeat this for the second flip flop.

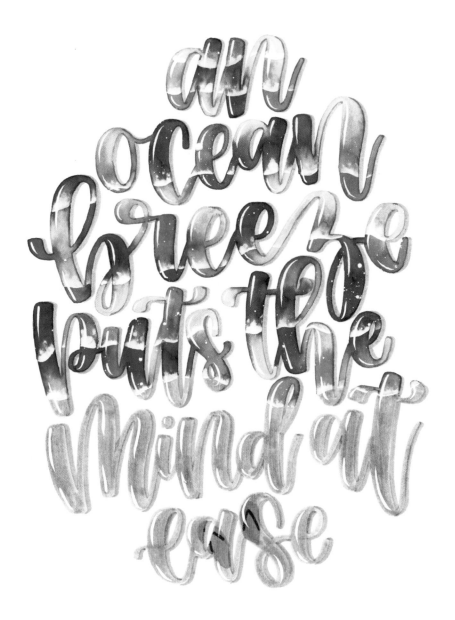

FINISHING TOUCHES: Add shadows using the gray brush pen and highlights using the dip pen and white paint as shown on page 32, "Adding Shadows & Highlights." For the top section with the waves, try to place the tapered end of the highlight in a section where there is blue so that the highlight is easily defined.

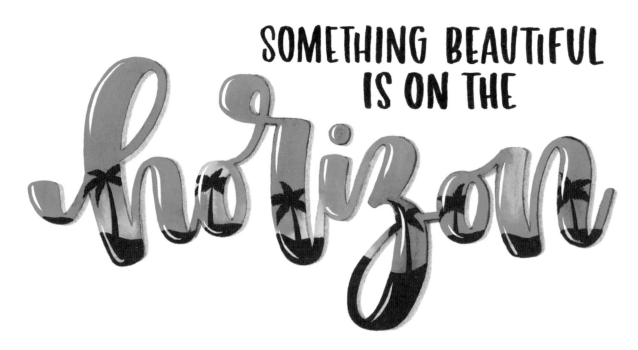

SOMETHING BEAUTIFUL IS ON THE *horizon*

PALM TREE SUNSET

My favorite part of going to the beach is watching the sunset, which is what inspired this project! When picking colors, I imagined the most beautiful sunset and picked vivid colors to match. I recommend sticking to the colors you'd typically find in a sunset, but you can absolutely make changes within this color scheme. For example, I used pink, orange and yellow for my sunset, but you can use another color combination—like blue, pink and just a bit of orange—if you want your lettering to capture a different part of the sunset.

This project makes use of black to create the silhouette of palm trees. While you could also draw the palm trees in full color, this is a quicker and easier way to get the same effect. You could use this technique to easily draw anything you'd like within your letters and it looks especially realistic when the objects are backlit, like in this case, since there isn't much light to illuminate them from the front anyways!

MATERIALS NEEDED
- Brush pens: light gray, gray, pink, orange, yellow & black—see the color palette on page 12 for specific brand color numbers
- Paper: mixed media
- Small round paintbrush & water
- Black fineliner
- Dip pen & white paint

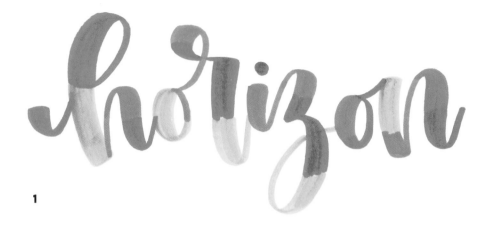

1

2

PREPARATION: Letter "horizon" using the Script Style (page 18) and a light gray marker.

STEP ONE: Take your pink, orange and yellow brush pens and fill in your lettering to prepare for blending. Instead of doing the usual alternating sections, I broke up the word into three sections and colored the top section pink, the middle orange and the bottom yellow to mimic the color layout of a sunset.

STEP TWO: Blend the colors together using your paintbrush and water. Allow the piece to dry completely.

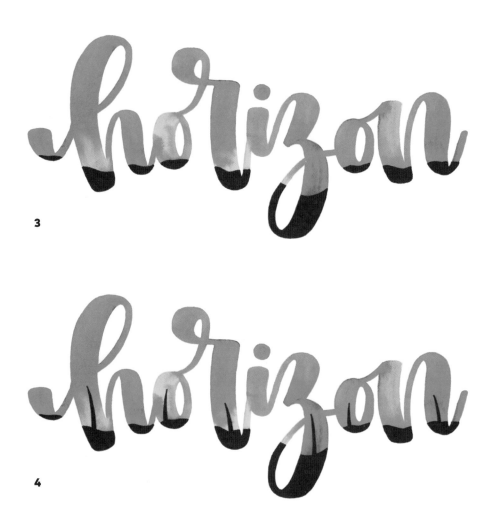

3

4

STEP THREE: After the blending has dried, take your black fineliner and color in roughly the bottom ½ inch (1.3 cm) of the lettering. This will be the ground that you'll add palm trees to later on. Since the ground naturally varies in height, it doesn't need to be perfectly straight. I purposely made it a bit uneven to add some variety and make it look more realistic.

STEP FOUR: Now, it's time to add in palm trees. Using the same fineliner, draw curved lines coming out from the ground, with the top of the line being a bit thinner than the bottom. These are the trunks of the palm trees. I like to only add one to every other downstroke so that it doesn't get too crowded.

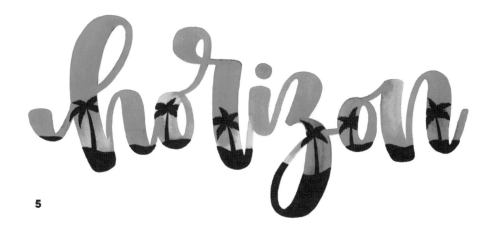

5

SOMETHING BEAUTIFUL
IS ON THE

6

STEP FIVE: Draw five small lines coming out from the top of each trunk for the leaves. Then, add short lines angled towards the end of the leaves as if you were drawing a feather to complete the leaves.

STEP SIX: Finish the quote by lettering "something beautiful is on the" above your sunset lettering using a black brush pen.

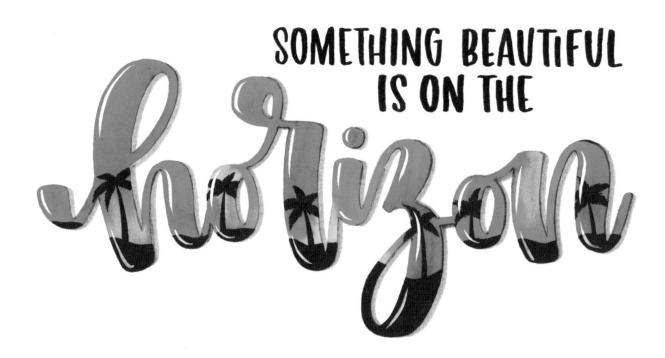

SOMETHING BEAUTIFUL IS ON THE *horizon*

FINISHING TOUCHES: Add shadows using the gray brush pen and highlights using the dip pen and white paint as shown on page 32, "Adding Shadows & Highlights."

MERMAID TAIL SCALES

In this project, we're moving away from the beach and into the ocean! This scale pattern is not only easy to create, but also extremely easy to customize. I used the Script Style because I think that the rounded structure of this style is a nice contrast to the repetitive pattern of the mermaid scales, but any of the three styles could work well.

For the colors, I chose to use pink, blue and teal, but feel free to choose whatever three colors you like! I prefer to stick to cooler colors for this design, but any colors could work as long as they are dark enough that you can clearly see the white scales over them. Aside from the brush pen colors, switching the white paint out with gold or silver paint or ink for the scales outline would also look great!

This project makes use of white as a shortcut, similarly to how the "Palm Tree Sunset" project (page 68) used black to create the silhouettes of the palm trees. In this case, we're using white to create negative space within the letters, making each colored section look like a small scale. Using white, you could draw and blend each scale individually to get a similar effect—this approach is significantly less difficult and time consuming.

MATERIALS NEEDED

- Brush pens: light gray, gray, blue, pink & teal—see the color palette on page 12 for specific brand color numbers
- Paper: mixed media
- Small round paintbrush & water
- White paint

PREPARATION: Start by lettering "mermaid hair, don't care" using the Script Style (page 18) and a light gray marker.

STEP ONE: Prepare your lettering for blending by using your three colored brush pens to fill in the light gray sketch. I used my usual technique of alternating sections of color, as seen on page 29.

> **TIP:** I shaped the apostrophe and comma like a rounded drop of water to go along with the water theme.

STEP TWO: Blend the colors using a small paintbrush and water. A lot of the bleeds will be covered up by white paint later on, so don't worry too much about making them perfect. Let this dry completely and wash your paintbrush before moving on to the next step.

1

2

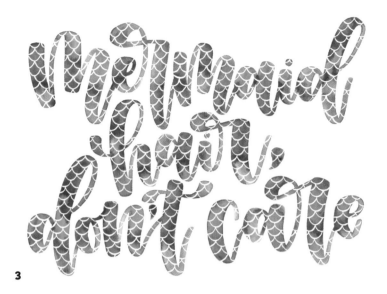

STEP THREE: Paint a row of semi-circles across the top of the lettering using the tip of your paintbrush and white paint to create the first line of scales. Each of my semicircles was about ⅓ inch (9 mm) wide, but this can vary depending on how large and wide your letters are. In general, roughly two full scales should fit within the thickest part of the downstrokes.

Next, paint a second row of semicircles, but offset them by half a semicircle. The highest point of each of the semicircles in this row should intersect the lowest point of each of the semicircles in the row above. This should create a shape similar to a teardrop.

Repeat this process moving downwards until you reach the bottom of the letter, then repeat for the rest of the quote.

3

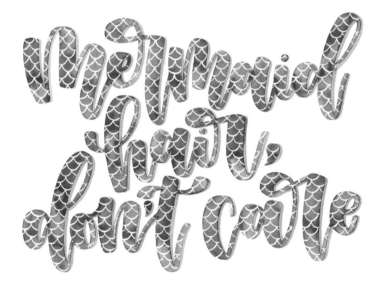

TIP: You could also use a dip pen for this step to get thin precise lines. If you choose to use a dip pen, I recommend turning the page 90 degrees to the right—left if you are left-handed—to avoid smudging.

FINISHING TOUCHES: Add shadows using the gray brush pen as shown on page 32, "Adding Shadows & Highlights." I chose not to add highlights to this project because they would intersect with the white scale outlines.

Shining lights

From dazzling shining stars to the bright lights of a marquee sign, this chapter focuses on adding different elements of light into your lettering. Recreating luminance with markers can be tricky, but this chapter will show you all of my favorite techniques to capture various types of light, like in my favorite project, "Star-Filled Galaxy" (page 78).

Since a big focus of this chapter is white paint, you can easily change most of the other colors in the upcoming projects without ruining any of the effects. I've added in some suggestions on how you can personalize each project, so feel free to customize things as you'd like!

From the shape of the stars in your galaxy to the shape of your string lights, this chapter will let your personal style shine!

STAR-FILLED GALAXY

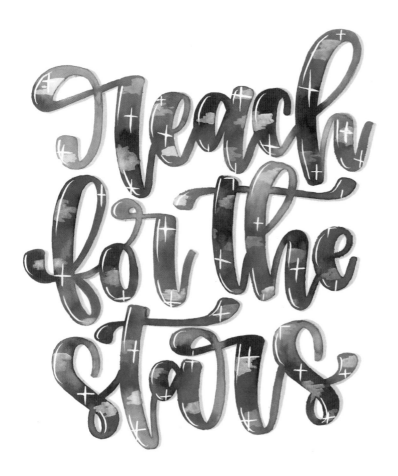

This popular lettering technique is one of my favorites because it is so fun and versatile. On top of that, it's also a relatively easy way to enhance your blended lettering without too much effort or expertise. You have full control over the colors and amount of added elements, so it's a great project for adding your own customization to make it even more unique!

I used pink, blue, purple and black for this piece, but you can choose whatever colors you want! Most color combinations would work well with this project, so feel free to choose your favorite colors instead. If you do decide to switch up the colors, I recommend including black because it helps give the effect of depth within the galaxy. You could also do all of the lettering in just black or dark blue if you want to skip the blending and just add in the stars.

MATERIALS NEEDED

- Brush pens: light gray, gray, pink, blue, purple & black—see the color palette on page 12 for specific brand color numbers
- Paper: Mixed media
- Small round paintbrush & water
- White paint
- Dip pen

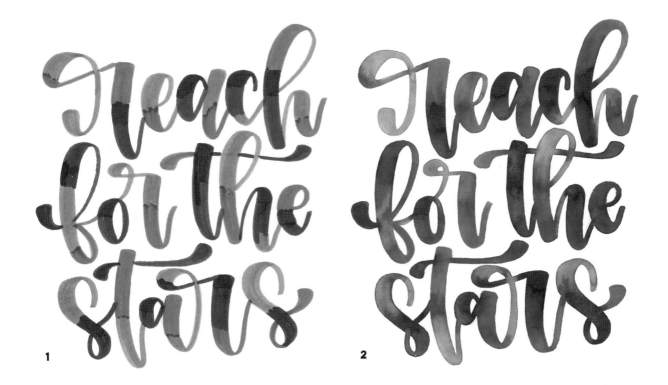

PREPARATION: Sketch out the words "reach for the stars" in the Script Style (page 18) using a light gray brush pen, making sure to thicken the downstrokes to create more room to add in stars and other elements later on. For now, just focus on the shape of the letters and don't worry about planning where each star or cluster will go.

STEP ONE: Pick out your colors and start preparing to blend. I laid out the colors similarly to how I normally do, but with one small change. Instead of doing an equal section of every color, I started the rotation by coloring in equal sections of pink, blue and purple. Then, I made sections for black about half the size of the other sections. This is done so that the black ink doesn't overpower the brighter colors when you start blending.

I purposefully chose to put the colors in this order—blue, pink, black, purple—for two reasons. First, putting black, the darkest color, next to pink, the brightest color, meant that I could lean into the contrast and create some beautiful bleeds where they meet. Second, avoiding putting purple in between blue and pink meant that I didn't have to worry too much about the purple getting lost as its own unique color, since blue and pink combine to make purple anyway.

STEP TWO: Blend the colors with your paintbrush and water. Don't be afraid of this not being perfect since you'll be covering a lot of it up in the next couple of steps. This project is particularly good for beginners because if you make a mistake or some of the blending doesn't turn out the way you want it to, you can just strategically cover it up with stars later on!

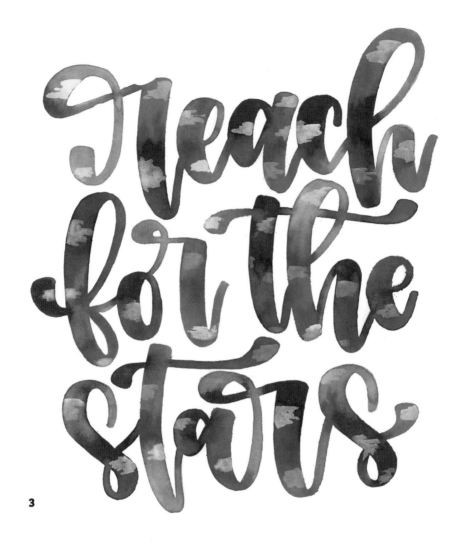

3

STEP THREE: Dilute some white paint for the star clusters and either wash your paintbrush or grab another one of a similar size. You want the paint to be a bit transparent so that the stars you add in later on will still be visible on top of it. Then, using your paintbrush, start making small cloud-like shapes by moving your brush in small circles. I tend to keep them near the edges of the letters since the downstrokes aren't thick enough to show the entire cluster in terms of width.

TIP: If a star cluster hits the side of a letter, continue it on the next letter to make the piece look more cohesive. I did this a few times in the example, like in between the "a" and "c" in the word "reach."

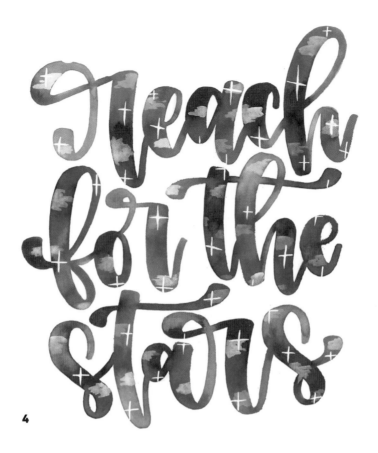

4

STEP FOUR: Now, it's time to add the individual stars! Take some white paint—this time more opaque—and either the same paintbrush or a dip pen. You want this to be more opaque than the clusters so that you can layer the stars on top. I prefer to use a dip pen for this step because I find it easier to get sharp and precise lines with the dip pen.

I create my stars by drawing a longer vertical line and crossing it at the center with a shorter horizontal line, but you can draw them however you like! To create the lines, I start by drawing lightly, then add more pressure as I get closer to the center and then taper off again on the other end of the line.

Popular variations include adding an "x" to the middle of the stars I used to create an eight-point star, the typical five-point stars or even just small dots. Feel free to mix and match any of these techniques within your galaxy.

> **TIP:** If you decide to use a dip pen for this step, make sure to turn the page 90 degrees before drawing the second line of the star, since the dip pen won't be able to create the taper if you try to draw a horizontal line.

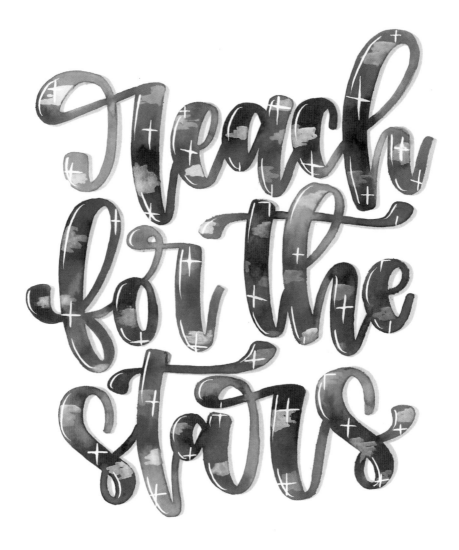

FINISHING TOUCHES: Add shadows using the gray brush pen and highlights using the dip pen and white paint as shown on page 32, "Adding Shadows & Highlights." Try to avoid going over the stars with highlights whenever you can so that you can still clearly see that they are stars. You can see me do this on the second "s" in "stars" where I started the highlight just below where the star and highlight would have connected.

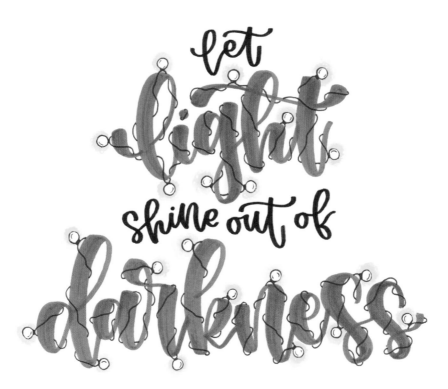

SPARKLING
STRING LIGHTS

This technique is reminiscent of the "Wrapping Vines & Leaves" project (page 47) from the Botanicals chapter, but this one puts a different spin on it by featuring luminous string lights. I chose to use blue for the lettering, but any color could work! I recommend sticking to lighter or mid-toned colors so that you can still clearly see where the black cords wrap around the lettering.

For the lights, I used sphere-shaped globe lights, but this could easily be altered to include different types of string lights. I've also tried this with Edison bulbs and colorful Christmas lights and both worked just as well! If you decide to use Christmas lights, you could easily change the quotes to make them more fitting for that time of year.

MATERIALS NEEDED

- Brush pens: blue, yellow & black—see the color palette on page 12 for specific brand color numbers
- Paper: mixed media
- Black fineliner (make sure to use one that has permanent ink, not water-based ink)
- Small round paintbrush & water
- White paint

STEP ONE: Letter the words "light" and "darkness" using your blue brush pen in the Script Style (page 18), leaving space above and between them to add in the rest of the quote later on.

STEP TWO: Using your black fine-liner, draw wavy lines around your letters, making it look as if the lines are wrapping around the letters. For the sections of the lines that are supposed to be behind, make sure to stop when you touch the outer edge of the letter and continue on the other side. Don't worry about having the lines connect as if they're all a part of the same string of lights.

Then, add small rectangles spaced out along the lines. These will be the bases for your light bulbs.

TIP: When adding the rectangles, keep in mind that you'll need enough space to add in the bulbs in the next step!

1

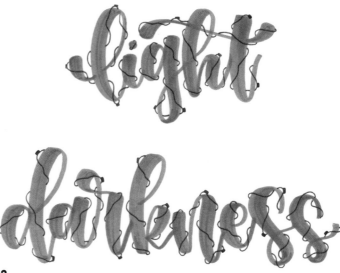

2

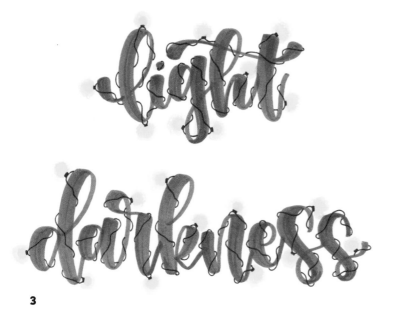

STEP THREE: Take your yellow marker and draw a yellow circle connected to each rectangle. Then, use a small paintbrush to add water and blend the circles so that the color is slightly diffused around the edges. Part of the diffused circle will go over the black rectangle's base, which is why it is important that your fineliner does not have water-based ink!

STEP FOUR: Using your paintbrush and white paint, draw a white circle that is slightly smaller than the yellow circles originally were. This circle should go directly over the yellow circle so that just the diffused edge of the yellow circle peeks out around it.

3

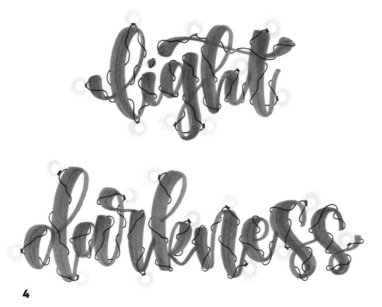

4

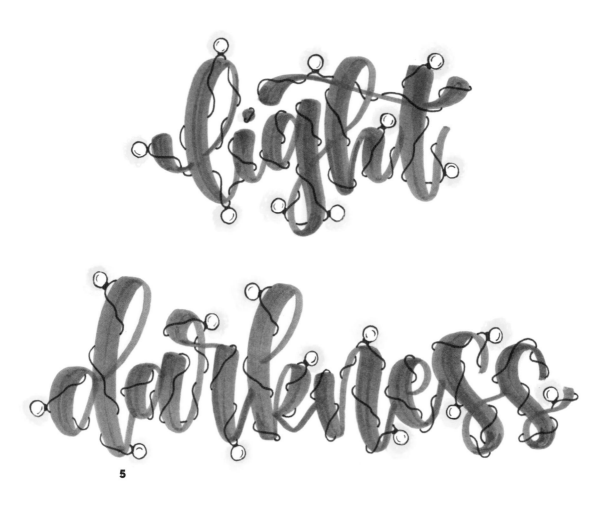

5

STEP FIVE: After the white paint has dried, grab your black fineliner and outline the white circles, making sure to connect the circle to the base of the light. I also added a few curved black lines inside of the circle to add some more details.

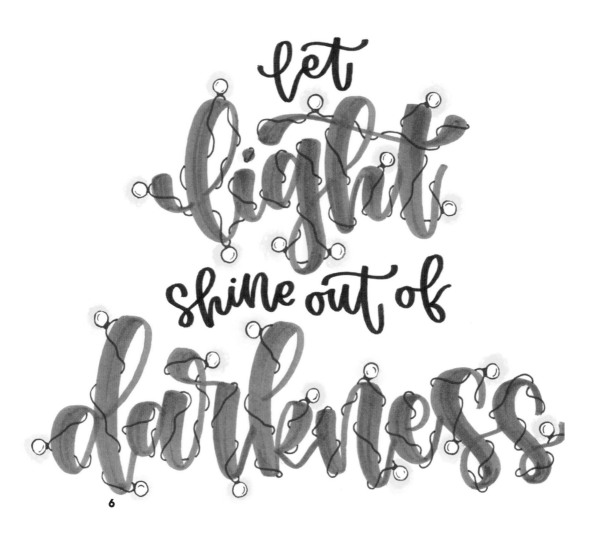

STEP SIX: Complete the quote by adding "let" above the word "light" and "shine out of" above the word "darkness" using a black brush pen and the Script Style (page 18).

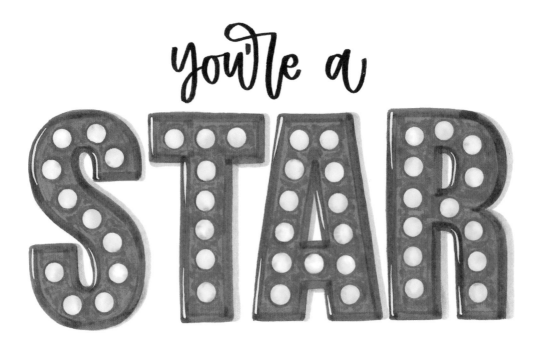

DAZZLING
MARQUEE LIGHTS

If you've dreamed about seeing your name in lights, this project is for you! These bold marquee lights work perfectly with the Block Style because the letters don't have any thin sections, so it's easy to add the lightbulbs in. The Print Style or Script Style could also work, but you'll need to slightly alter them to make the letters Monoline so that the lightbulbs will fit.

This project is on the simpler side, but that just means that there is plenty of room for customization! Since the color choices don't play a huge role in the project, you could easily change the color of the outer rim, the inside of each letter, and/or the lights. I'd recommend avoiding lighter colors for the inside portion, since it works best if that section is darker than the lights. Besides that, almost any variation should work just fine. I also think it would look great if the letters had a pattern on them or the lights were multicolored!

MATERIALS NEEDED

- Brush pens: light gray, gray, maroon, red, yellow & black—see the color palette on page 12 for specific brand color numbers
- Paper: mixed media
- Pencil
- Small round paintbrush & water
- Dip pen & white paint

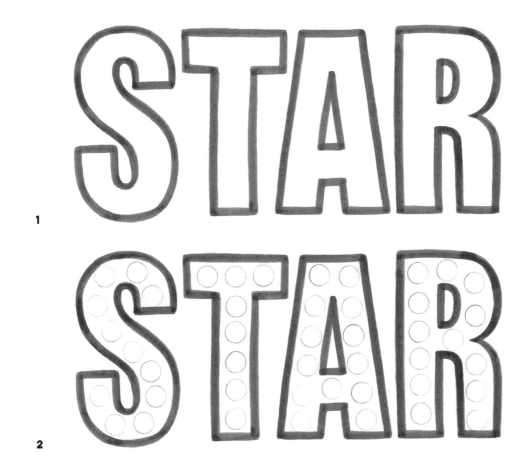

1

2

PREPARATION: Start this piece by outlining the word "star" in the Block Style (page 20) using a light gray marker.

STEP ONE: Using your maroon brush pen, trace over the light gray outline to create the outer rim of the letters. I wanted the width of each line to be roughly the same, so I turned the page as I drew so that I was always drawing vertically. By doing this, I was able to avoid the oval shape of the brush pen affecting the line; instead, it created a Monoline effect while also keeping the corners sharp.

STEP TWO: Next, using a pencil, lightly draw circles in the center following the shape of the letters. These circles will become the lightbulbs in the center of each letter. I kept the circles pretty close together, but you could make them as sparse or crowded as you'd like, as long as the edges are not touching.

The goal for this step is just to figure out where you want to place each circle, so don't worry about making the circles perfectly round. However, make sure that they are all approximately the same size so that you have an accurate idea of how they will fit inside of the letters. I traced around a marker cap to keep the size of the circles consistent. You could also use a coin or button depending on how big your letters are.

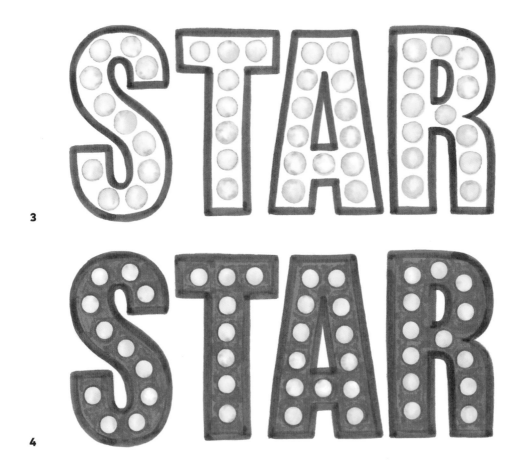

3

4

STEP THREE: Trace over the circles with your yellow brush pen, leaving the center of each circle blank. Then, blend the yellow ink using your paintbrush and water. Since only the perimeter was outlined in yellow, it should create a nice gradient effect with the center being the lightest point, as if a light was shining from inside the lightbulb.

The exact shape of the lightbulbs still does not matter. Just focus on blending and creating the gradient for now, as any uneven circles will be easy to fix in the next step.

STEP FOUR: Now, it's time to fill in the rest of the letters. This is where it's important to pay attention to making the circles as perfectly round as you can. Start by outlining each circle with your red brush pen. I traced around the same marker cap to keep everything consistent.

Then, color in the rest of each letter using the same red brush pen.

you're a

STAR

5

you're a

STAR

STEP FIVE: Using a black brush pen, letter the words "you're a" above "star" in the Script Style (page 18).

FINISHING TOUCHES: Add shadows using the gray brush pen and highlights using the dip pen and white paint as shown on page 32, "Adding Shadows & Highlights." I kept the highlights on the maroon rim of the letters since that part should look like it's a bit raised.

Geometric Patterns

In this chapter, we will focus on building patterns within our lettering based on repetitive shapes.

None of the projects in this chapter have elements that go outside of your lettering, so this is your chance to show off your perfected lettering technique.

These patterns require attention to detail and precision in a different way than a lot of the other projects, since each repetition of the pattern needs to be as precise as possible so that everything is uniform. Expect to get lots of use out of your pencil and ruler along the way to create your beautiful, finished product!

Unlike in the previous chapters, none of these require blending, so mixed-media paper and water are not required. However, you could definitely add some blending in if you'd like, and I've included some suggestions for how to do so in each tutorial.

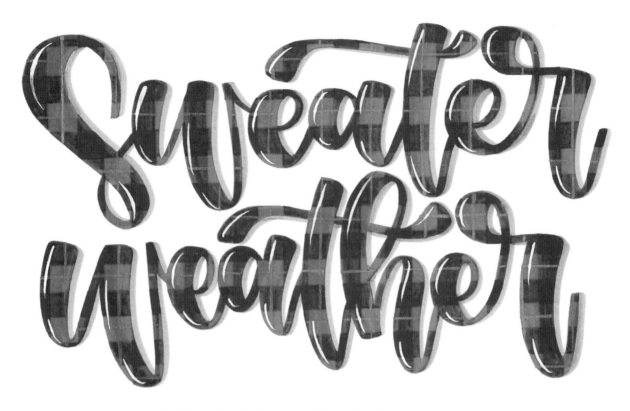

PERFECT PLAID

This technique was one of the first patterns I tried, and it's still one of my favorites. It can get a bit tedious the first time you try it, but the final result is so worth it. I chose to use the Script Style because it nicely contrasts the rigid structure of the plaid design, but you can use this technique with any style.

This project doesn't require water-based brush pens or mixed-media paper, but if you'd like to add an extra effect to this project, try adding an extra color and blending the base with water and a paintbrush. Some of my favorite color combinations for this are red + pink or red + burgundy.

MATERIALS NEEDED

- Brush pens: red, gray & black—see the color palette on page 12 for specific brand color numbers
- Paper: printer or mixed media
- Ruler
- Pencil & eraser
- Small round paintbrush and gold ink, paint or a gel pen
- Dip pen & white paint

1

2

STEP ONE: Letter the words "sweater weather" onto your paper using a red brush pen using the Script Style (page 18). This creates the base layer that you'll build the plaid pattern upon. I chose to use red for this piece, but any color besides black and gray will work well.

STEP TWO: Using your ruler and pencil, lightly draw equally-spaced vertical lines going across the length of the words. Then, draw horizontal lines from the top to the bottom to create a grid. Don't worry if it's messy because the grid will be erased later!

I usually make the squares roughly ⅓ x ⅓ inch (9 x 9 mm), but you can make them bigger or smaller depending on your preference and how large you'd like the words to be. The bigger you make the squares, the bigger the pattern will be, so keep that in mind as you're sketching your grid.

STEP THREE: Take your gray brush pen and fill in every other vertical column of the grid within the letters. Then, repeat the process for every other horizontal row. Make sure to only add gray inside of the red letters.

TIP: If you're having trouble visualizing which rows and columns to fill in, try drawing a little dot in pencil at the top of every other line so that you can easily see which ones need to be colored in.

STEP FOUR: Using your black brush pen, fill in every square where the gray lines intersect. This, in combination with the gray lines, gives the illusion that the gray lines create darker squares where they overlap. In the past, I've tried to get this effect by overlapping the gray lines without the black squares, but I prefer taking the extra step of adding black because it makes the pattern much more pronounced and dramatic.

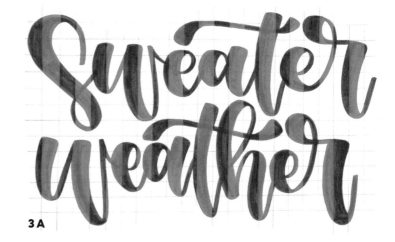

3A

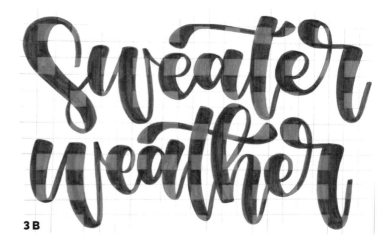

3B

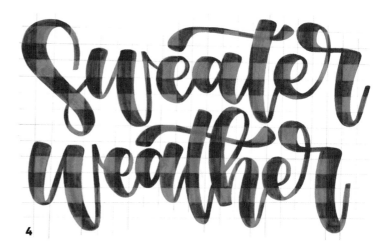

4

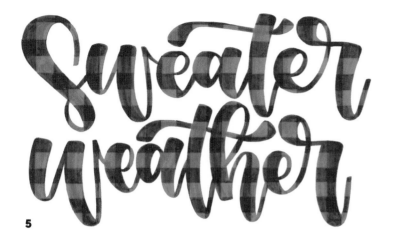

5

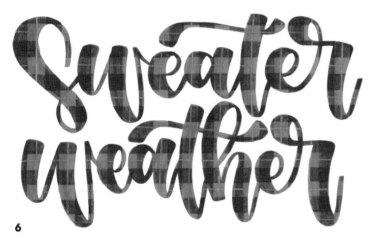

6

STEP FIVE: Now that you've drawn in the plaid pattern, it's time to erase the grid. This step is relatively straight-forward, but be careful! Wait a minute or two before erasing to give the ink some time to dry so that it doesn't smudge when you start erasing. Once the ink is dry, gently erase the grid until all of the pencil marks are gone.

STEP SIX: Now, add a parallel gold line to every row and column that you didn't add gray to in Step Three. Essentially, you're copying the same pattern as the gray lines, but moving it over one column and down one row. There are a few ways to do this, but I like to use a small paintbrush and gold watercolor paint. You can also use a gold gel pen, but I prefer paint because it's easier to make the line opaque.

TIP: An easy way to double-check that the gold lines are in the right place is to make sure that the gold doesn't go through any of the black squares.

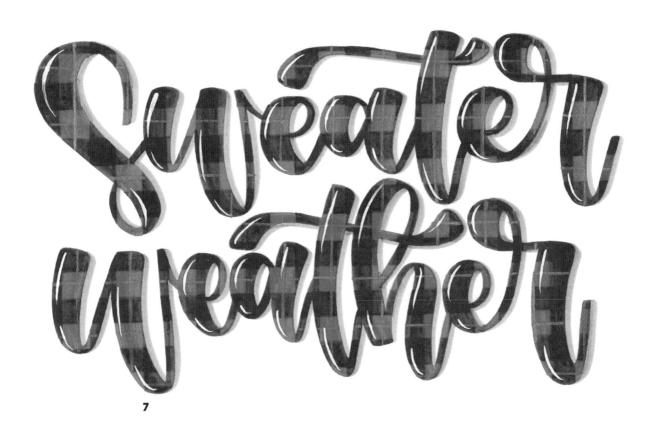

7

STEP SEVEN: Add shadows using the gray brush pen and highlights using the dip pen and white paint as shown on page 32, "Adding Shadows & Highlights."

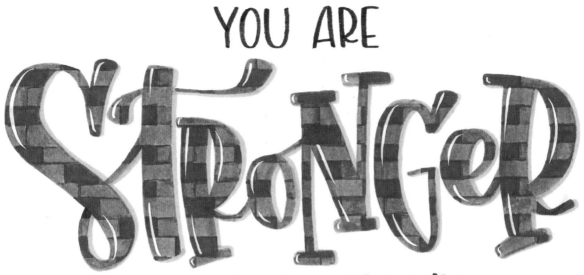

YOU ARE STRONGER THAN YOU THINK

BRICK WALL

This pattern may seem simple, but it requires some attention to detail in order to get the pattern right. It's a great way to build your skills with pattern lettering! Once you get the hang of it, you can customize the colors however you'd like. I kept the colors realistic by using three shades of brown, but you could also add in a bit of orange or red to brighten it up a bit. Or, you could go for a more colorful look and use more vibrant colors. I think that a combination of pink + blue + purple or alternatively red + orange + yellow would look great!

Any of the three styles could work for this project, but I recommend using the Print Style, which is what I did. The Block Style would also work well. Since these two styles don't have too many rounded curves, it will be easier to see the pattern and you'll be able to minimize how many bricks get cut off at the edges of the letters.

MATERIALS NEEDED
- Brush pens: light gray, gray, light brown, brown & dark brown—see the color palette on page 12 for specific brand color numbers
- Paper: printer or mixed media
- Pencil & eraser
- Ruler
- Black fineliner
- Dip pen & white paint

1

2

PREPARATION: Letter the word "stronger" using your light gray brush pen in the Print Style (page 22). Note: The gray sketch shown in the image above was added digitally for clarity.

STEP ONE: Start the pattern by creating a grid for the bricks. Using a pencil and ruler, draw a horizontal line across your lettering. Continue drawing horizontal lines going down the length of your letters, with each line spaced about ⅓ inch (9 mm) apart.

Now that you have your rows of bricks laid out, it's time to define each individual brick. Within the first row, draw vertical lines approximately 1 inch (2.5 cm) apart across the entire grid. Skip the next row and draw the same vertical lines on the third row. Repeat this process on every other row going all the way down.

Then, in all of the rows that are still blank, repeat the process of drawing vertical lines, but offset them by ½ inch (1.3 cm). The middle of each brick should intersect with the ends of two bricks above and below it.

STEP TWO: Take your dark brown marker and in the first row, color in every third brick. Make sure to fill in only the parts of the brick that have lettering inside of them, as these sections will build the letters and reveal the lettering you've already done. This is why the light gray outline is especially important.

Then, offset the pattern by two bricks on the next row so that no two bricks of the same color touch. Repeat this pattern of two rows going down until you reach the bottom of the gray outline.

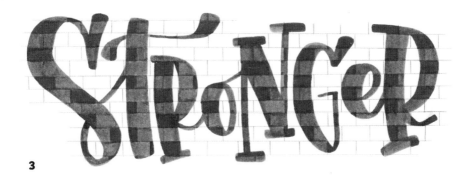

3

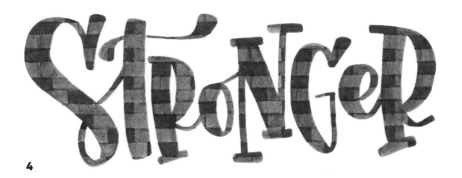

4

STEP THREE: Now, let's fill in the rest of the bricks. Continue the pattern with your brown and light brown markers, offsetting the pattern each time to fill in the remaining bricks.

When finished, no two bricks of the same color should be touching, and each line should follow an alternating pattern between the three colors. Give the ink time to dry before moving on to the next step.

STEP FOUR: Erase the pencil grid so that just the marker ink is left. The pencil marks outside of the letters need to be completely erased, but the lines inside of the letters don't necessarily need to be fully erased since you'll go over some of the same spots with the black fineliner in the next step. It's better to leave some of the grid lines inside of the letters than to erase too hard over the ink and cause the paper to peel.

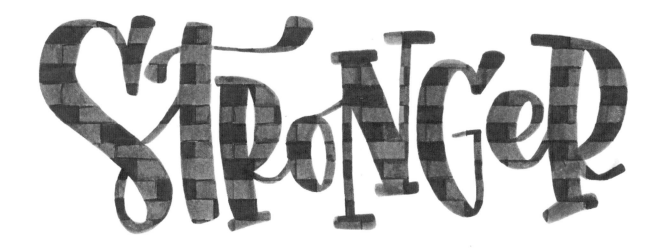

5

STEP FIVE: Take your fineliner and start loosely outlining some of the bricks. I didn't use any specific pattern for this—I just tried to space it out enough so that the bricks looked defined but they weren't all outlined. I purposely made this a bit messy.

YOU ARE STRONGER THAN YOU THINK

6

STEP SIX: Take a black brush pen and write the words "you are" above and "than you think" below the word "stronger." I used the Print Style (page 22) for this step.

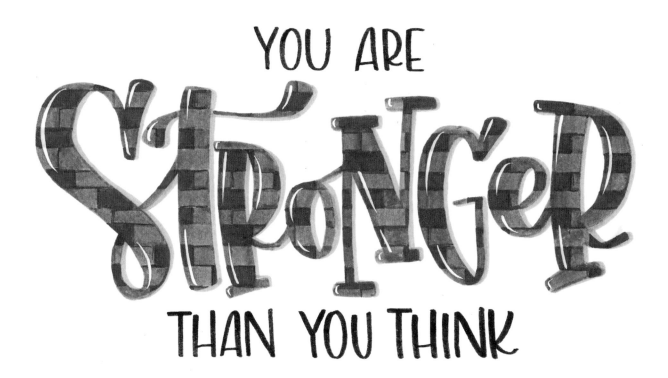

YOU ARE STRONGER THAN YOU THINK

FINISHING TOUCHES: Add shadows using the gray brush pen and highlights using the dip pen and white paint as shown on page 32, "Adding Shadows & Highlights."

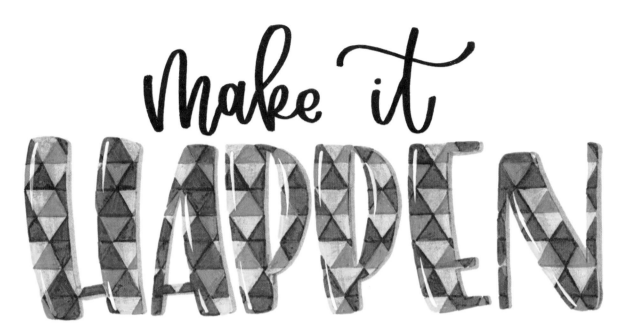

COLORFUL
TRIANGLE GRID

This fun triangular pattern requires just three easy steps! I originally did this pattern with shades of gray to resemble the Times Square New Year's Eve Ball, but this variation is far more colorful, which makes it easier to distinguish where each triangle is placed. Of course, you can choose whatever colors you'd like! My only recommendation is that you choose four colors in order to stick with the pattern that is shown in Step Two.

For the lettering style, any of the three styles could work, but I'd recommend choosing either the Print Style, which is what I used, or Block Style. The triangle shapes combined with the rounded curves of the Script Style might end up looking too busy.

Similar to the "Brick Wall" pattern (page 99), this project looks relatively simple, but takes a lot of planning and concentration to get the pattern right. Don't worry, though. As long as you stick to the pattern, you should be fine!

MATERIALS NEEDED
- Brush pens: light gray, gray, pink, yellow, green, blue & black—see the color palette on page 12 for specific brand color numbers
- Paper: printer or mixed media
- Pencil & eraser
- Ruler
- Dip pen & white paint

1

PREPARATION: To start, letter the word "happen" using the Print Style (page 22) using a light gray brush pen. Make the downstrokes as wide as possible so that you have lots of room to draw your pattern inside the letters. Note: The gray sketch shown in the image above was added digitally for clarity.

STEP ONE: Use your pencil and ruler to draw a horizontal line across your lettering. Draw parallel horizontal lines going down the length of your lettering, with each line about ½ inch (1.3 cm) apart.

Then, draw lines at a 45-degree angle to the horizontal lines, with each angled line about ½ inch (1.3 cm) apart. I like to turn the page 45 degrees to make this easier, since then you'll be drawing the lines in the same direction as you did for the first set.

To finish the grid, draw lines that go through the intersections of the two previous sets of lines, creating a grid of triangles.

TIP: To make this easier, I like to rotate the page every time I start a new set of parallel lines. That way, I'm always drawing horizontal lines and don't need to worry about drawing at a weird angle.

2A

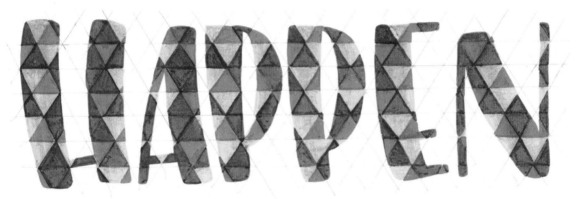

2B

STEP TWO: Take your four colorful brush pens and begin filling in the triangles using the pattern shown to the right, one color at a time. If you stick to this pattern, no two triangles of the same color should touch. I've found that adding one color at a time is easier than switching between all four colors and working your way across the word. Let the marker ink completely dry to avoid smudging in the next step.

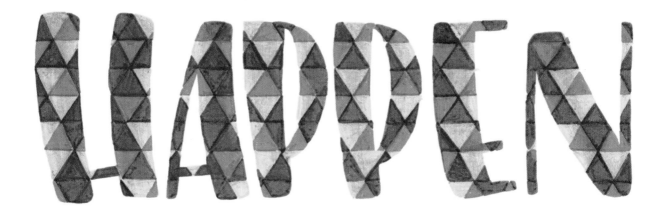

3

STEP THREE: Erase the pencil grid as best you can, focusing on erasing the lines outside of the lettering completely. Since you added ink on top of the pencil, some of the lines may not fully erase, but they can help give definition to the triangles.

TIP: If a pencil line isn't easily erasing, that's okay. It's better to leave a few faint lines in than to erase too hard and cause the paper to rip.

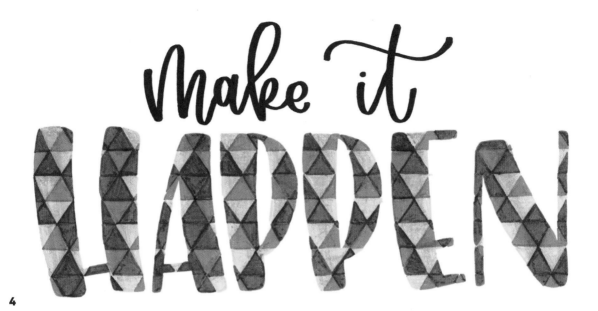

4

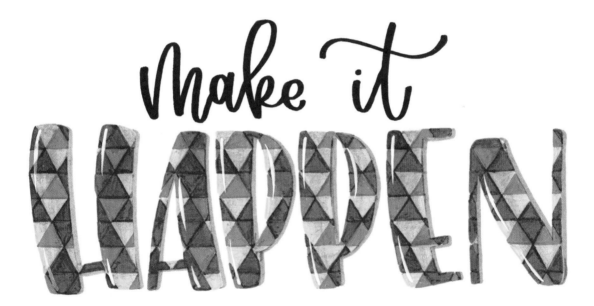

STEP FOUR: Finish the quote by lettering "make it" above your triangular lettering using your black brush pen. I used the Script Style (page 18) to add a bit of roundness into the piece.

FINISHING TOUCHES: Add shadows using the gray brush pen and highlights using the dip pen and white paint as shown on page 32, "Adding Shadows & Highlights."

Sweet Treats

Last up is arguably my favorite chapter—Sweet Treats! In this chapter, I turn some of my favorite sweet treats into lettering and teach you how to add a sprinkle of creativity into your own lettering.

While personalizing the projects is always encouraged, I recommend sticking to the suggested lettering styles for these projects to match the shapes of the items we are aiming to recreate. However, there are plenty of opportunities to change the colors or words to better fit your taste. For example, there are so many fun dessert-related quotes and words that could be swapped into these projects, like "life is what you bake it" and "save room for dessert." Or, you could switch a quote from one project to another, like by using "the best things in life are sweet" with the donuts instead of the waffles.

Keep reading to find out all of the ingredients for turning your lettering into sugary foods and even a drink. Trust me, I've saved the best for last!

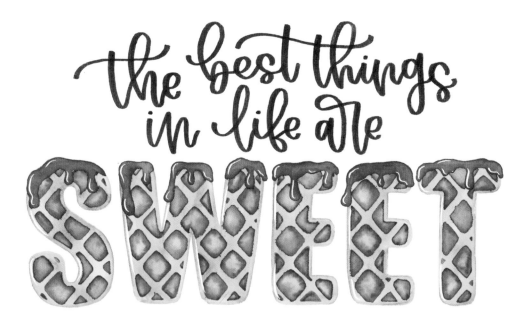

WARM WAFFLES
& SYRUP

This is one of the most detailed and time-consuming projects in this chapter, but the finished result is so eye-catching, it's well worth it! I used the Block Style for two reasons—the structured look is the most similar to a waffle, and the balance of width between the upstrokes and downstrokes gives lots of space for the detailed pattern to be added in. To make it look even more realistic, I rounded the corners a bit to give a bubbly effect and used multiple shades of brown to create shadows and the illusion of depth within the waffle.

While I don't recommend changing the style of the lettering, there are lots of options to change the colors! Feel free to change the flavor of the syrup, add more toppings, or even change the color of the waffle to make it a different flavor.

MATERIALS NEEDED

- Brush pens: light brown, brown, dark brown & black—see the color palette on page 12 for specific brand color numbers
- Paper: mixed media
- Small round paintbrush & water
- Pencil & eraser
- Ruler
- Dip pen & white paint

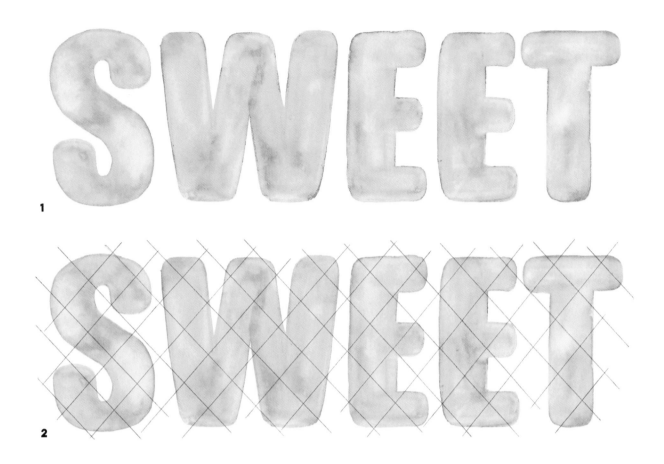

STEP ONE: Letter the word "sweet" using a light brown marker. I chose to use the Block Style (page 20), but I rounded the corners and edges to give a fun bubbly effect to the letters.

Even though this step only uses one color, I blended the ink with water to minimize the overlapping lines. This is optional, but the variations in color that come from blending help mimic the look of natural variance in something that was baked.

STEP TWO: Using a pencil and ruler, lightly draw diagonal lines across the letters with each line being about ½ inch (1.3 cm) apart. Then, draw a perpendicular set of diagonal lines to create a grid of ½-inch (1.3-cm) squares. This sets up the structure of the waffle.

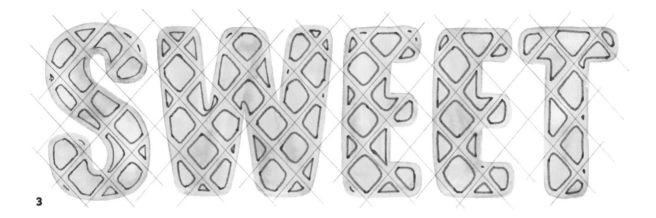

3

STEP THREE: Now it's time to start adding in the details! Take your brown marker and draw a rounded square inside of one of the squares in the grid. You want the edges of the rounded square to be about 1⁄16 inch (2 mm) away from the lines in the grid so that the square fits nicely inside. Repeat this process within the rest of the grid to create the dips in the waffles.

Once you get to the edges of the letters, there will be places where full rounded squares won't fit. Follow the shape that is made by the grid and the edges of the letters meeting and keep your brown lines 1⁄16 inch (2 mm) away from touching the grid or edges of the letters. It's okay if you end up with some weird shapes.

TIP: If you're having trouble visualizing the shapes at the edges, try drawing the lines that go right along the edges first and then go back and fill in the rest of those shapes.

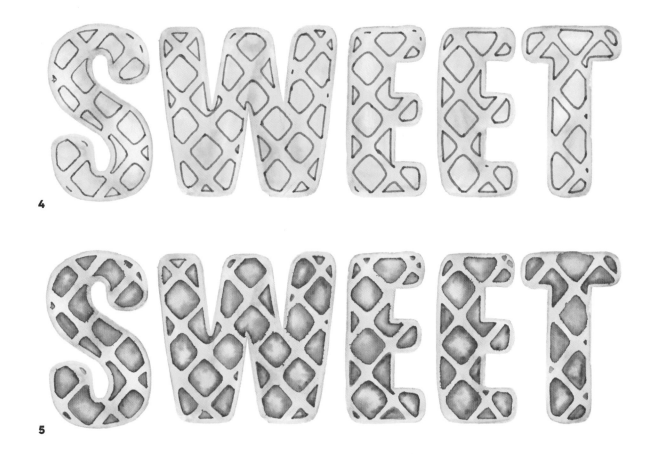

4

5

STEP FOUR: Next, erase the pencil grid. I like to do this here rather than at the end because there is less of a chance that you will cause the paper to peel because you haven't added water to the squares yet, which will take a while to dry.

STEP FIVE: Using your small paintbrush and water, add a small drop of water to the center of one of the rounded squares. Then, trace the inside edges around the perimeter of the square so that the ink starts to bleed into the center. This technique keeps the color more concentrated at the edges, which creates some nice natural variation in color. Repeat this process for all of the brown squares in the waffles. Let everything dry fully before moving on.

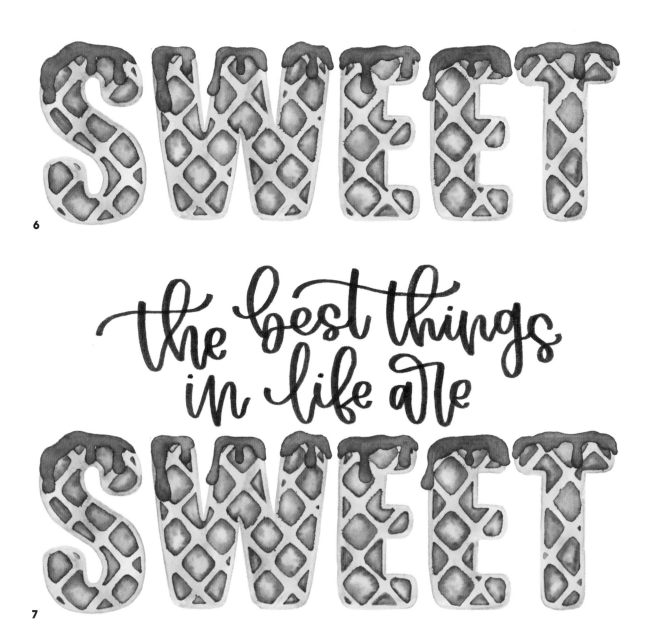

STEP SIX: Draw some loose blobs and drips at the top of each letter with your brown marker, with the drips falling down the sides for the syrup.

STEP SEVEN: Letter the words "the best things in life are" on top of "sweet" using a black brush pen and the Script Style (page 18).

the best things in life are SWEET

FINISHING TOUCHES: Add highlights (see page 32) to the drips as well as the waffle pattern using a dip pen and white paint. For the syrup, I added highlights to the side of every drip and any raised areas at the top. I like to keep the highlights especially close to the left edge of the letters for this project so that they sit on the lighter/higher parts of the waffle rather than in the dips to give a more realistic effect.

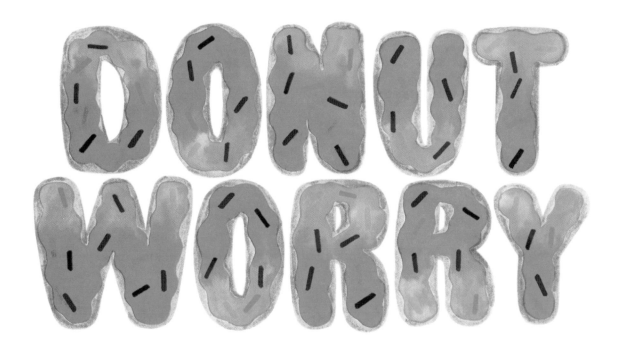

SPRINKLED DONUTS

These fun donut letters are a bubbly and colorful lettering project that you can easily customize. I chose to add pink frosting and rainbow sprinkles, but feel free to switch up the color of the frosting, the donut base or even the toppings. I think that this could look nice with other toppings like a chocolate drizzle and fresh fruit like strawberries. Or, if you're feeling adventurous, you could incorporate what you've learned in previous projects, like making a galaxy frosted donut!

Like in the "Warm Waffles & Syrup" project (page 112), I rounded the corners of each letter in the Block Style to make it look bubblier and more similar to what a donut would look like. I mimicked the holes (also known as counters) within the letters by making them the holes in the donuts, but you could also experiment with making the donuts look like they are filled by covering that space with icing.

MATERIALS NEEDED

- Brush pens: light gray, gray, light pink, pink, light brown, blue, green, yellow & red—see the color palette on page 12 for specific brand color numbers
- Paper: mixed media
- Pencil & eraser
- Small paintbrush & water
- Dip pen & white paint

1

2

PREPARATION: Lightly outline the words "donut worry" using the Block Style (page 20) and your pencil. Round the corners and then trace over the rounded letters with a light gray marker and erase the pencil lines.

STEP ONE: With your light pink marker, draw wavy lines inside the perimeter of each letter. This should mimic the shape of each letter but not touch the edges. Then, fill it in, alternating between your two pink brush pens. Since you drew the initial outline with the lighter shade, you'll be able to easily layer the darker color on top.

TIP: If you need some extra help planning where the icing should fall, draw a line in the center of the donut using your light gray marker. Then, plan your wavy lines on each side.

STEP TWO: Blend the icing using a small paintbrush and water.

Let everything dry completely before moving on. If the ink is still wet before you move on to the next step, it will bleed into the edges of the donut, which is not preferable. Keeping all of the lines clean and precise is especially important in this piece since there aren't many opportunities in future steps to cover up mistakes.

STEP THREE: Take your light brown marker and fill in the space within the letters around the icing. This is the base of the donut. If you'd like, you can blend this with water as well to make it better match the icing. Since these are such tiny spaces, there shouldn't be too many obvious over-lapping marker lines. If you decide to blend this layer, make sure to let it dry before moving on.

STEP FOUR: Using your blue, green, yellow and red markers, add short lines dispersed around the icing for the sprinkles.

TIP: If any of the pink ink bled into the brown or the lines aren't precise, add a sprinkle hanging halfway off of the icing to cover it up.

3

4

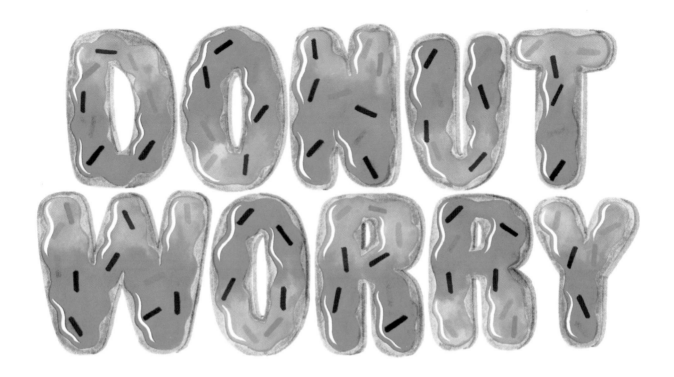

FINISHING TOUCHES: Add shadows using the gray brush pen and highlights using the dip pen and white paint as shown on page 32, "Adding Shadows & Highlights."

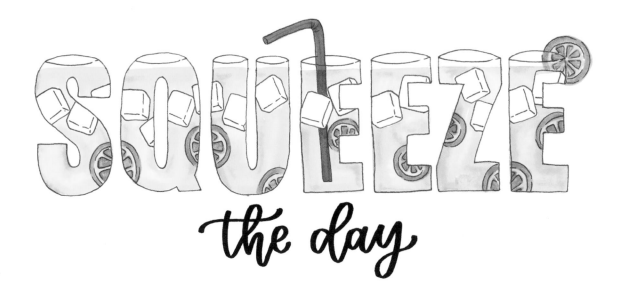

ICE-COLD LEMONADE

This is the most unique project in the chapter because, although it's sweet, it's the only one that's a drink! Unlike the other sweets, this project incorporates lots of sharp corners and precise lines, especially since some of the most striking elements, like the glass and ice cubes, aren't even the main focus.

I recommend using the Block Style like I did, since you want as much room as possible to draw the lemonade, but there are still so many things about this project that you can change. Some easy ways to customize this project are to simply change the colors—like by using shades of pink instead of yellow to make pink lemonade—or even to make a different drink entirely! Once you get the hang of creating the glass and how the drink and ice should look inside of it, the possibilities are endless in terms of what you can fill it with.

MATERIALS NEEDED

- Brush pens: yellow, dark yellow/gold, blue & black—see the color palette on page 12 for specific brand color numbers
- Paper: mixed media
- Pencil & eraser
- Black fineliner
- Small round paintbrush & water

1

PREPARATION: Start by outlining the word "squeeze" using a pencil and the Block Style (page 20). Unlike most of the other projects, using a pencil for the outline instead of a light gray marker is important since the top portion of the outline won't be covered with marker ink and will need to be erased.

STEP ONE: Using your pencil, draw a row of squares near the top of the letters about three-quarters of the way to the top. These will be your ice cubes. Then, turn these into 3D cubes by drawing another square behind and slightly below the first one and connecting them at the corners.

Using your black fineliner, trace the over the cubes. Then, erase the pencil lines. I chose not to outline the part of the second square that falls behind the first in order to give the cubes an opaque look.

> **TIP:** If you want a simpler variation, try drawing regular squares for a 2D ice cube effect.

2

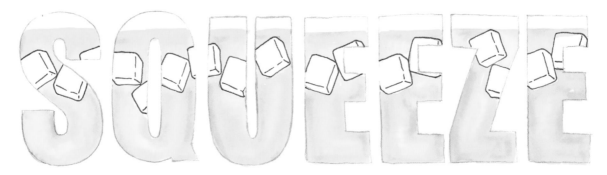

3

STEP TWO: Next, it's time to add in the lemonade. Take your yellow marker and trace the inside perimeter of each letter, only going up to slightly above where the ice cubes start. Then, add a thinner line to the outer edge of the yellow section using your dark yellow marker.

You want the ice cubes to sit nicely at the top of the lemonade and the top of the letter to remain white, since that will be the top unfilled portion of the glass.

STEP THREE: Using your paintbrush and water, blend the yellow and dark yellow ink by putting water in the center of the letter and tracing over the brush pen ink. Feel free to add bleeds to create a watery effect.

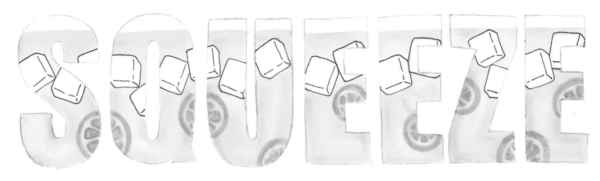

4

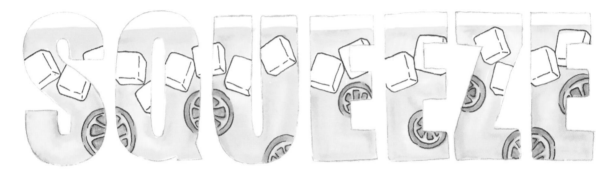

5

STEP FOUR: Take your orange marker and draw circles inside of the letters, ending the circle if it hits the edge of a letter. Then, draw triangles starting from the center going out for each wedge of the lemon.

STEP FIVE: Take your black fineliner and outline the lemons inside of each glass. I outlined these elements by adding short lines instead of one solid outline, but that's just a personal preference.

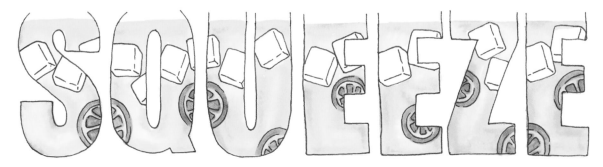

6A

6B

STEP SIX: Then, outline your letters with the same black fineliner, stopping at about seven-eighths of the way up the glass.

To create the top of the glass, draw a thin oval connecting the unfinished edges. I left a small section of the oval blank to look like there is a bit of glare on the glass. I also left an extra gap in the first "E" so that I could add a straw coming out of the glass in the next step.

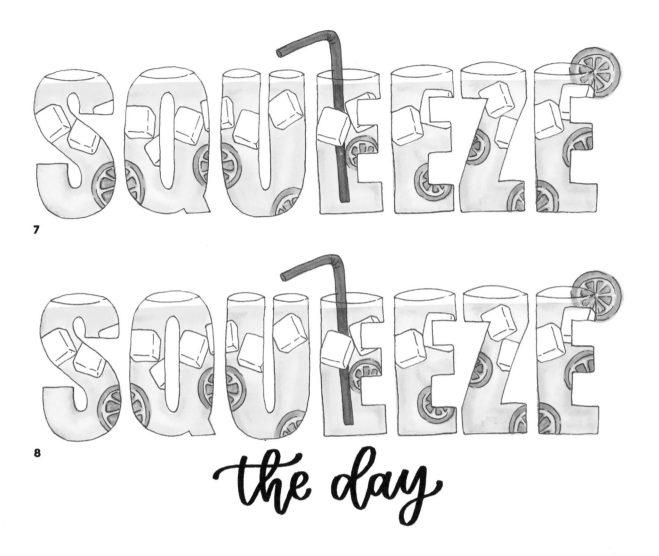

7

8

STEP SEVEN: Using your blue marker, draw a long line coming out of the first "E."

Then, draw a smaller line connecting to it at an angle to complete the straw. Take your yellow marker and draw a circle near the rim of the last "E" for a garnish, making sure to avoid overlapping with the ice. Then, using your dark yellow marker and the same process from before, add details to the lemon. Finally, outline the straw and lemon with your black fineliner, avoiding the section of the lemon that falls below the rim of the glass to give the illusion that the section is behind a layer of glass.

STEP EIGHT: Finish the quote by lettering the words "the day" underneath using your black brush pen and the Script Style (page 18). I chose not to add highlights and shadows because the highlights would interfere with the ice cubes and adding shadows would make it look like the glasses are lying horizontally on the page rather than giving the effect that they could be standing upright.

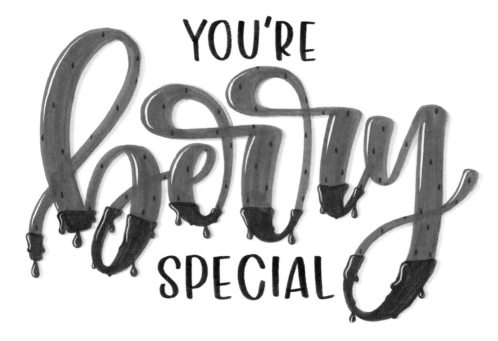

CHOCOLATE-COVERED STRAWBERRY

This sweet technique is the only one in this chapter that I used the Script Style for, so it definitely stands out. Similar to the "Warm Waffles & Syrup" project (page 112), this project uses the drip technique to create a mouth-watering chocolate dip effect. However, this time, it's on the bottom of the letters instead of the top, so you have more opportunity to create full drips of chocolate falling off of the letters. You could even add a drip or two in the space below the letters to make it seem like it just fell off.

One of the easiest ways to customize this is by changing the color of the dip, like by switching it to white chocolate or colorful candy melts. You could choose one of these or mix them and do one color per letter. If you want to take this to the next level, you could even add some fun toppings!

MATERIALS NEEDED

- Brush pens: light gray, gray, red, brown & black—see the color palette on page 12 for specific brand color numbers
- Paper: mixed media or printer
- Pencil & eraser
- Black fineliner
- Dip pen & white paint

1A

1B

2

PREPARATION: Letter the word "berry" using your light gray marker. I used the Script Style (page 18) for this and made the downstrokes thicker to allow more room for the details. Then, using a pencil, draw a wavy line horizontally across each letter about one-third of the way up.

> **TIP:** I made the two "r"s different heights so that they wouldn't overlap and would be easy to distinguish. This also helps give a fun bouncy effect to the lettering.

STEP ONE: Now, it's time to start adding color! For everything above the wavy lines, color it in red. Then, color everything below the lines in brown.

STEP TWO: After the marker ink has fully dried, erase the pencil lines so that just the red and brown lettering is showing.

STEP THREE: Next, we're going to be working on the chocolate. Using the same brown marker, add drips on the sides of each letter. I do this by drawing a small circle either beneath or on the side of the letter and then connecting it to make a drop.

Then, add a bit of width to the letters right where the chocolate meets the strawberry. This gives the effect that it was dipped and shows that the chocolate is sitting on top of the strawberry, meaning that the letters should be thicker there, which clearly defines where the chocolate begins.

STEP FOUR: Take your black fineliner and add small teardrop shapes to the red section for the strawberry seeds. It's best to keep these very small and all facing in the same direction for a more realistic look.

TIP: If you want to sketch this before going in with the fineliner, feel free to use a pencil first. The black ink is dark enough that the pencil marks won't show through even if they don't fully erase once the marker ink is placed on top.

3

4

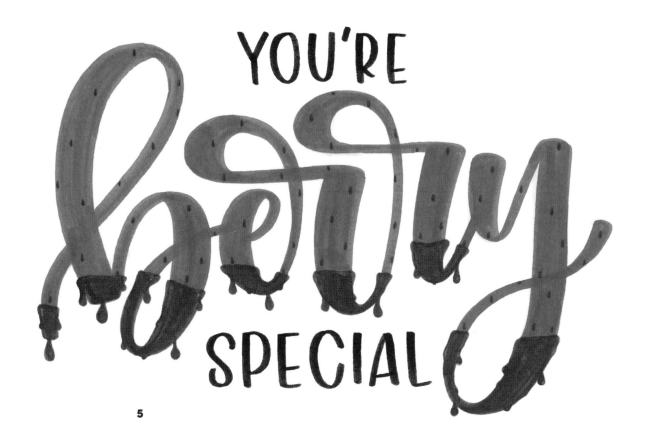

YOU'RE *berry* SPECIAL

5

STEP FIVE: To finish the quote, letter the word "you're" above and "special" below the word "berry" using your black brush pen. I chose the Print Style (page 22) for this step because it adds a bit of contrast to the roundness of the Script Style.

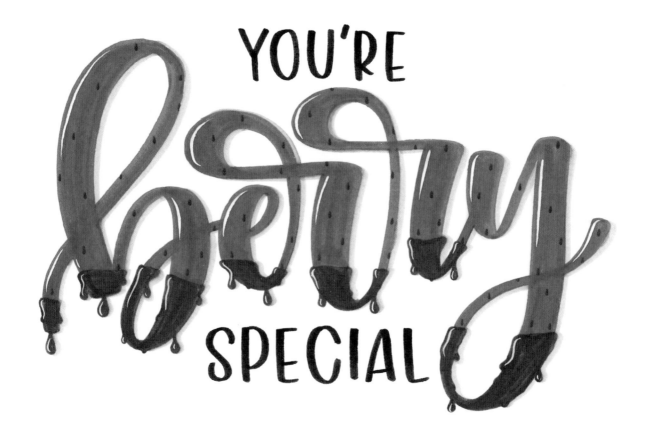

YOU'RE *berry* SPECIAL

FINISHING TOUCHES: Add shadows using the gray brush pen and highlights using the dip pen and white paint as shown on page 32, "Adding Shadows & Highlights." I also added a small highlight on each chocolate drip to make them pop. When adding shadows to the right of the letters, make sure to trace around the chocolate drips as well.

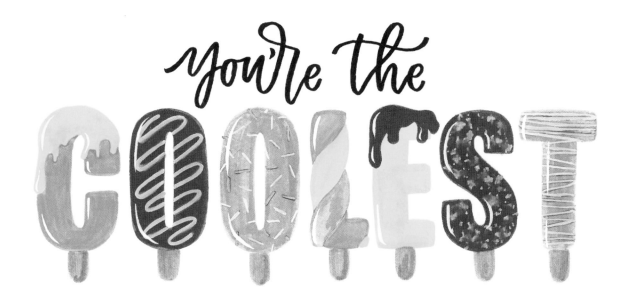

ICE CREAM BARS

This ice cream bar design is such a fun way to close out the chapter! There are so many different ways you can customize this project, but it's especially important that you come up with a plan. Since "coolest" has seven letters, I had to come up with seven variations for the ice cream bars before I started adding color in. Some easy ways to add variety are adding sprinkles, drizzles or nuts, or by having a bar be dipped in chocolate. Feel free to switch up the designs or colors to make it more unique to you! Once your plan is in place, the rest of this project is relatively straightforward.

I recommend sketching out your plan on a separate sheet of paper rather than sketching on the sheet of paper you plan on using for the final piece. This way, you can change the layout as many times as you'd like without worrying about ruining your project. Plus, keeping it on a separate sheet of paper means that you can easily use it as a reference and even add notes regarding the colors or decorations on each bar.

MATERIALS NEEDED

- Brush pens: light gray, pink, yellow, blue, light brown, brown & black—see the color palette on page 12 for specific brand color numbers
- Paper: mixed media
- White paint
- Small round paintbrush
- Dip pen

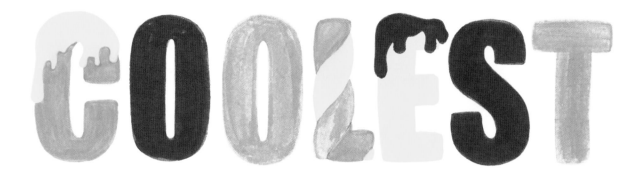

1

PREPARATION: To start, take your light gray marker and sketch out the word "coolest" in the Block Style (page 20). I rounded the corners slightly to give it a softer look and make each letter look more like an ice cream bar.

STEP ONE: I started by filling in all of the solid sections of color. This included the bases of all of my letters but did not include things that would be layered on, like sprinkles and drizzles, since we'll get to those later.

I chose not to blend these layers. Although I don't want marker lines, I also don't want there to be much variation in color. While blending can help with reducing marker lines, the variation in color shades, especially in a dessert-focused project, can make the end project look like something that was baked—see "Warm Waffles & Syrup" on page 112 for an example of how to use this to your advantage. Instead, I opted to add multiple layers of marker ink

to create an even and vibrant wash of color. I purposely chose colors that were on the lighter side so that they would build up nicely without being too overpowering.

TIP: If you change the design and aren't sure if you should color something in now or not, an easy way to determine this is by thinking about whether or not that section of color would be necessary to complete the shape of the letter. For example, the brown dip at the top of the letter "E" isn't necessarily part of the base of the ice cream bar, but without it, you wouldn't be able to tell that it's an "E." Things like the sprinkles on the second "O" don't meet that criteria, so they weren't filled in during this step.

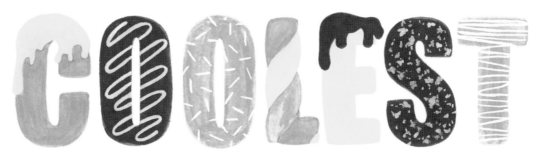

2

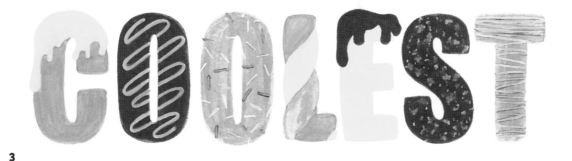

3

STEP TWO: Next, grab your white paint and a small paintbrush to add some fun details. You may need a few layers of white to get a nice opaque finish. This is important because it will allow the colors of the decorations to be vibrant since they are not being put directly over another layer of color.

For the first "O," I drew a long wavy line across the letter diagonally to create a drizzle. On the second "O," I drew short lines for sprinkles. Then, I added small blobs of white to the "S" by lightly tapping my paintbrush up and down for the nuts. For the "T," I added a thinner white line going back and forth across the letter for a slightly different drizzle.

Everything in this layer will be white, but you'll add color in the next step after the white paint has completely dried!

STEP THREE: Now it's time to add color to your decorations. I wouldn't recommend picking colors that are in the base of the letter you're decorating for this step, but besides that, it's up to you! For example, on the second "O," I used every color besides blue because the base was already blue.

> **TIP:** I recommend using a light hand for this so that the white paint doesn't get on the tip of your marker. Even when the paint is dry, this can sometimes happen since both the marker ink and the white paint are water-based. If white paint residue gets on your marker, there's no need to panic—just immediately draw a few quick lines on a clean sheet of paper to wipe it off.

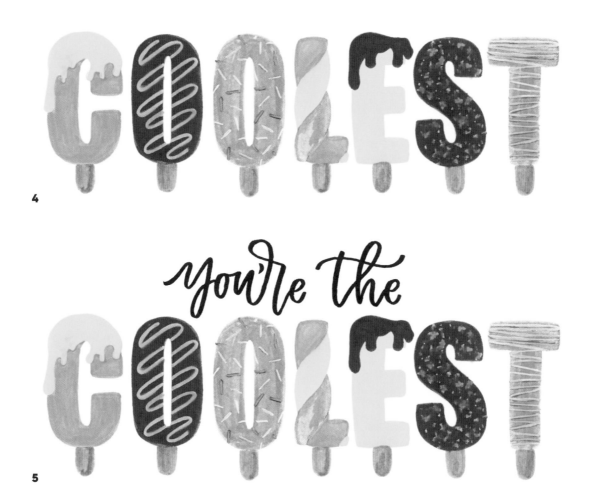

4

5

STEP FOUR: Using your light brown marker, draw a long rectangle at the bottom of each letter, being sure to round out the bottom edges so that they look like popsicle sticks.

STEP FIVE: Letter "you're the" using the Script Style (page 18) and your black brush pen. I chose this style because it contrasts nicely with the structured look of the Block Style.

you're the
COOLEST

FINISHING TOUCHES: Add highlights (see page 32) on the left of each letter using a dip pen and white paint. I chose not to add shadows but if you do, make sure to also add a shadow to the popsicle sticks.

ACKNOWLEDGMENTS

I'd like to thank the lettering community, who not only share their beautiful art but also encourage, teach and inspire others to express themselves through lettering. I learned lettering by going on social media and taking inspiration from the artists who were willing to share their art and teach others, so the fact that I've now come full circle and am able to teach others who are starting where I did is mind-blowing.

I'd also like to thank my editor, Sarah, along with the rest of the Page Street team for not only believing that I could write a book in the first place, but also supporting me along the way.

ABOUT THE AUTHOR

Marcella is a self-taught lettering artist and the creator of the blog Lovable Letters. She's been creative since a young age and started dabbling in lettering before she even knew it had a name. She first tried to properly teach herself lettering in 2016 but gave up after a few days. In 2020, after a few years of on-and-off practice, Marcella decided to start lettering again on her Instagram @lovableletters. Now, she has the pleasure of teaching hand lettering and modern calligraphy to others all over the world, through her worksheets, tutorials and workshops.

Mainly working with markers and watercolor, Marcella creates bright and colorful lettering projects. Many of her lettered pieces are inspired by landscapes, patterns and objects that she sees in her everyday life. She hopes that her lettering inspires others to explore their own creativity as well.

Aside from lettering, Marcella is a classical singer who holds a bachelor's degree from Peabody Conservatory of The Johns Hopkins University and is currently pursuing a master's degree at Mannes School of Music.

INDEX